30 Minute Artist

Painting
Flowers in
Watercolour

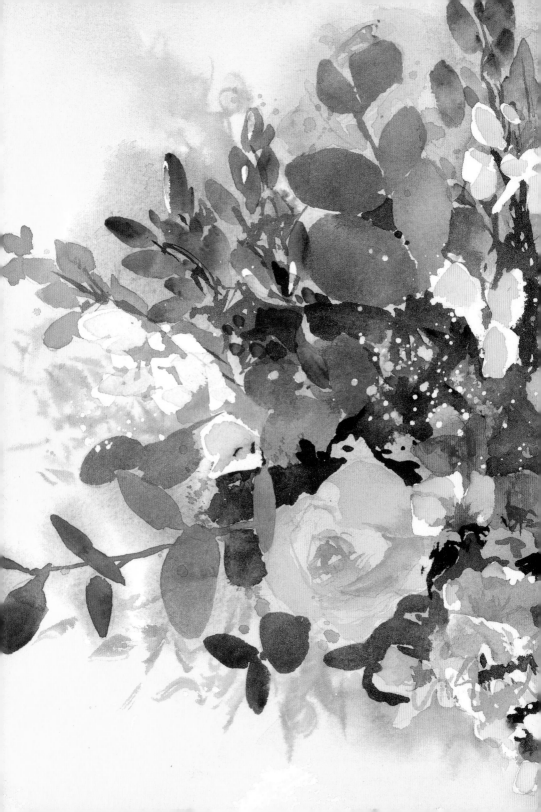

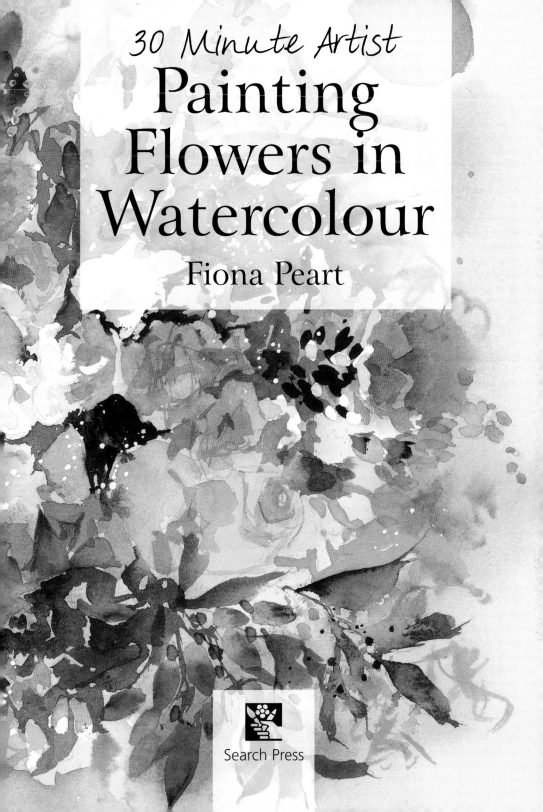

30 Minute Artist
Painting
Flowers in
Watercolour

Fiona Peart

Search Press

First published in Great Britain 2013

Search Press Limited
Wellwood, North Farm Road,
Tunbridge Wells, Kent TN2 3DR

Text copyright © Fiona Peart 2013

Photographs by Paul Bricknell at
Search Press Studios

Photographs and design copyright
© Search Press Ltd 2013

ISBN: 978-1-84448-826-1

Suppliers
If you have difficulty in obtaining any of the materials
and equipment mentioned in this book, then please
visit the Search Press website for details of suppliers:
www.searchpress.com

You are invited to visit the author's website:
www.fionapeart.com

Printed in China

Dedication
For Terry – each half hour is precious.

Acknowledgements
The words and the paintings are just
part of a much bigger picture when it
comes to writing a book. My sincere
thanks goes to Edward Ralph, my
wonderful editor, for doing such a great
job, as well as Paul Bricknell for doing all
of the photography in this book.

My thanks also go to all of the staff at
Search Press who work so hard behind
the scenes to ensure success in all
departments, from all the office staff,
to Bernie and the boys shifting all the
heavy boxes in the warehouse. They are
always smiling, helpful and a great team
to work with.

Page 1:
Tea Time
18.5 x 19cm (7¼ x 7½in)

Pages 2–3:
Mixed Bouquet
32 x 24cm (12½ x 9½in)

Opposite:
Birthday Roses
18.5 x 10.5cm (7¼ x 4in)

Contents

Introduction 6

How to use this book 8

Materials 10

Colour 14

Using a round brush 16
Wet strokes on dry paper 16
Controlled shapes on dry paper 18
Letting the shapes merge 20
Lifting and releasing the brush 22
Double loading the round brush 24
Overlaying or glazing 26
Spattering 28
Teasing and bruising 30
Scraping and moving paint 32
Dropping in 34
Lifting out 36
Combining the techniques 38

Using an angled brush 40
Scribbling with the point 40
Controlled strokes 42
Double loading the angled brush 44

Using a stippling brush 46

Using salt 48

Using masking fluid 50

Backgrounds 52
Background or vignette? 52

PROJECTS 56
Jug of Daffodils 56
Roses 60
Blue Iris Vignette 64
Lilies 68
Roses and Buddleia 72
Rose Posy 76
Sunflowers 80
Brompton Stock 84
Window Flowers 88
Spring Violas 92

Index 96

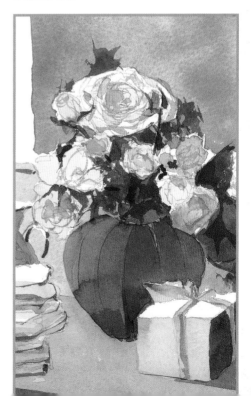

Introduction

Most of us just want to dive in and start painting, but spending a little time thinking and planning really will result in greater success. This does not mean spending hours in consideration; but using those snippets of time when we can not paint to store a few ideas, we can just get on with it when we do have that luxury of half an hour to paint.

If you are lucky enough to have the space to enable you to leave your art materials set up, then all of your preparation can be done beforehand, the drawing can be done and your paints can be all ready to go – right down to a clean, inviting water pot just enticing you to dip a paint-coloured brush into it! If it is not possible to leave your art materials out anywhere, you can still prepare everything in advance so that when you get a spare half hour you can quickly put everything on a table, fill your water pot and paint.

When you find the time to paint, it can be so exciting not to have to waste time wondering what to do, but to have everything at hand ready to just go for it. The results are always fresh and vibrant, with the added advantage that you do not have time to fiddle – the resulting paintings are often better the less time you spend on them.

How often I hear people say 'oh, I often overwork watercolour.' Well, giving yourself just half an hour will stop you doing that. Once you put those finishing touches to your painting, walk away from it. When you come back to it, how wonderful it will look, and all in just half an hour!

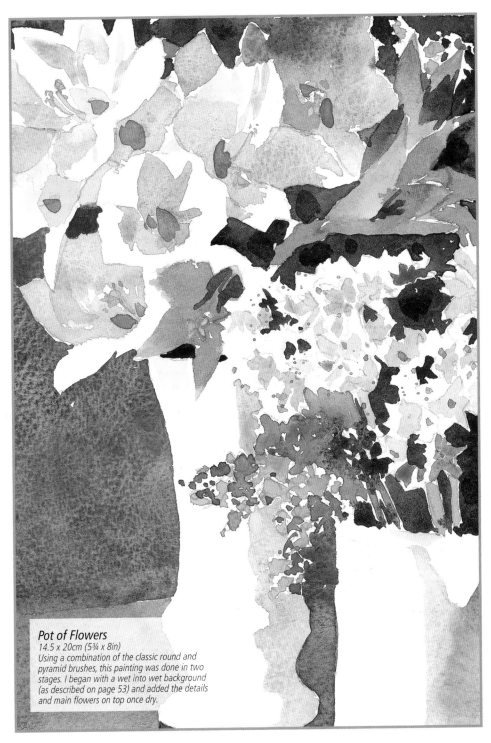

Pot of Flowers
14.5 x 20cm (5¾ x 8in)
Using a combination of the classic round and pyramid brushes, this painting was done in two stages. I began with a wet into wet background (as described on page 53) and added the details and main flowers on top once dry.

How to use this book

Many of us do not have as much time as we would like to paint, but by developing a looser approach to painting and using our time wisely, we can enjoy the time we do have and create something worthwhile.

Each of the techniques needed to paint in this way are described individually over the following pages, starting with the most basic and increasing in complexity as you follow the techniques through the book. After the techniques there are ten projects with step by step instructions, which use the techniques learnt in the first section of the book. If you first practise the techniques before attempting the projects you will have more success. Some of these techniques you may know, and you may also have more of your own that you can use to adapt the projects and make them your own.

I hope that by using and enjoying this book you will add to your painting skills and produce some wonderful paintings of which you can be proud.

In this quick sketch, bluebell and Naples yellow were placed side by side and invited to touch and merge in places (see page 20). The wet paint was then teased across the paper in places using an embossing tool (see page 30).

An artist's eye

Learning to look may seem like an obvious thing to do, but looking is very different from actually seeing. Once able to see with an artist's eyes, translating the world around us can be very exciting.

Our subjects can be found anywhere; we can observe flowers and foliage in gardens, parks and streets. There are ornate floral displays in hotel foyers, offices and reception areas, and we can be inspired by photos in magazines and gardening programmes on television. Wherever we see flowers or foliage, we should notice what we find appealing and learn to observe.

So what should we look for? Flowers can protrude from the top of the stem, as with tulips, or can be attached directly to the stem, as with heather. Bluebells each have a stalk which is attached to a single stem. Alliums have single flowers which are on stalks of nearly equal length coming from one point. However, it is not just the blooms that are important, and the rest of the plant must be carefully observed, too.

All plants have growing systems, which means that their flowers and leaves will always be arranged in the same way in any given plant. Each flower, leaf and stem has its own individual shape which, in turn, has a position that shows it to its best advantage. Once we add a number of parts together the task of the artist is to show these subjects in a simple and clear way. The advantage of being a painter is that we can change things to suit us. If we arrange a pot of flowers, but some are facing the wrong way, we can alter our composition and not stick rigidly to what is actually in front of us.

Observation is so important; once we know what to look for, painting flowers becomes so much easier.

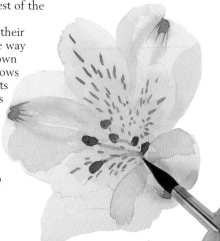

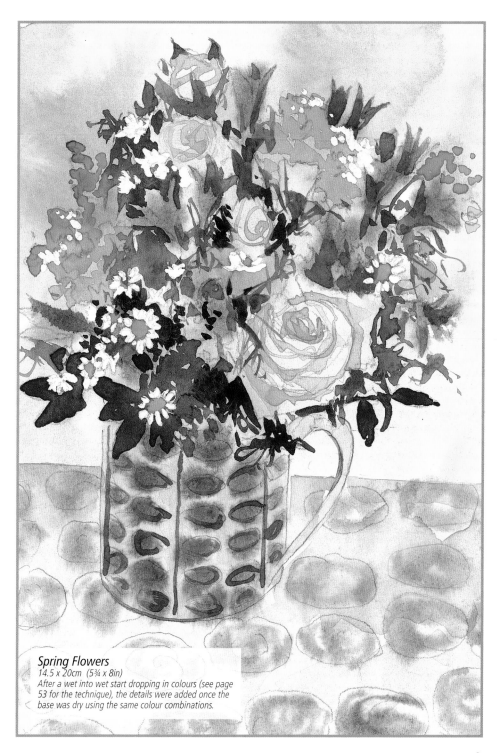

Spring Flowers
14.5 x 20cm (5¾ x 8in)
After a wet into wet start dropping in colours (see page 53 for the technique), the details were added once the base was dry using the same colour combinations.

Materials

Brushes

I use a combination of soft wash/stippling brushes and squirrel hair brushes. I prefer to use natural hair brushes as I use wet watercolour techniques which lend themselves to using this type of brush. Natural hair, such as sable or squirrel, holds the liquid in the brush and releases it each time I apply pressure to the brush head against the paper. The following brushes are those that I prefer to use. If you use others, look for similar qualities to ensure that the techniques work correctly.

Golden leaf This is the largest brush I use for watercolour. It is wonderful for applying and lifting liquid on to and off the paper as well as creating a variety of textural effects when used as a stippling or pouncing brush. A flat hog brush can be substituted for many of the same effects.

Stippler This is made from the same hair combination as the golden leaf; simply at a smaller size. A small hog brush makes a good alternative.

Classic round My classic round is the brush I use most for traditional painting techniques. Equivalent to a size 12 round brush, it is ideal for blocking in areas of colour, moulding shapes using the whole length of the brush, as well as creating fine details using the tip. It releases paint uniformly with each tap against the paper. Made of squirrel hair, it is beautifully soft and gently caresses the paper when releasing paint.

Pyramid Made from the same type of hair as the classic round, this is a beautifully-shaped asymmetric brush, rather similar to a dip pen. It is ideal for achieving angled brush strokes and more creative strokes. A short sword brush may be substituted for some techniques.

Pointer The equivalent to a size 6 round brush, the pointer is designed to gently release paint in a controlled way, as well as to allow fine details to be added to work. The central core is synthetic whilst the outer hair is the same as the classic round and pyramid brushes. The outer section acts as a reservoir, gently releasing the paint down the synthetic core.

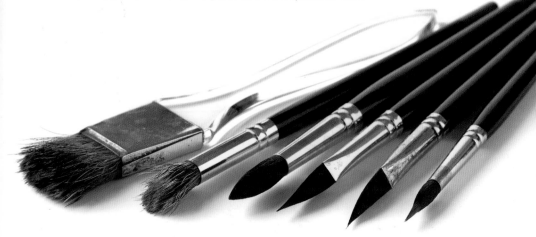

Paints

There are so many different brands of watercolour paint on the market but, broadly speaking, watercolour paints are available in two qualities: students' quality or artists' quality. Student's quality paints have more binder and filler added to them. They are cheaper but sometimes have inferior pigments to the artists' quality paints. Artists' quality paints flow better, are more vibrant and are more pleasing to work with. I believe it is better to have fewer colours of artist's quality paint, than a large selection of student's quality colours. I use various brands but the colours I have are all artists' quality.

The colours I have used in this book are: cadmium yellow, cadmium yellow deep, cadmium orange, Naples yellow, raw sienna, burnt sienna, permanent rose, opera rose, permanent magenta, shadow, bluebell, French ultramarine, cobalt blue, Winsor blue (green shade), cobalt turquoise light, sunlit green, country olive and midnight green.

Country olive may be substituted with olive green; midnight green with Hooker's green; bluebell with a mix of permanent rose with French ultramarine or cobalt blue; and shadow with French ultramarine, burnt sienna and permanent rose.

Each of the projects (see pages 56–92) is accompanied by swatches like the ones above to show which colours I have used. If you do not have the exact paint in your collection, simply use the swatch as a reference point for a substitute, or to mix a similar colour yourself.

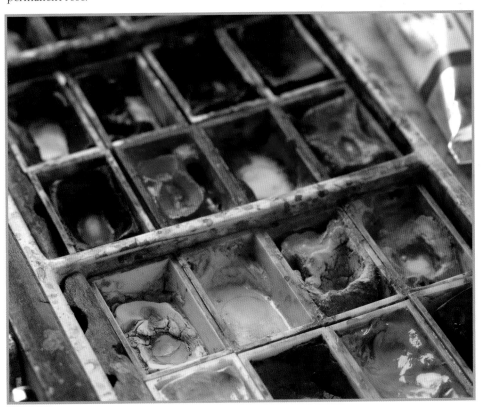

Paper

Watercolour paper is available in various weights and surface textures, from smooth to rough. I use Bockingford watercolour paper which is a wood pulp paper as well as Saunders Waterford which is a cotton rag paper, both are made at the St Cuthbert's paper mill in Somerset.

I tend to use 300gsm (140lb) weight, but you should feel free to use any watercolour paper weight or surface that you wish.

Materials for creating effects

Masking fluid A liquid latex used for preserving white or light areas prior to applying paint.

Masking fluid brush A synthetic brush used for applying masking fluid.

Palette knife This is used for gently moving paint.

Salt This is used to create texture when applied to a coloured wet surface.

Kitchen paper This is very useful for lifting colour and cleaning the palette.

Embossing tool/darning needle This is used for bruising the paper and teasing out colour.

Ruling pen/colour shaper When applying masking fluid in fine lines or dots, one of these is very useful.

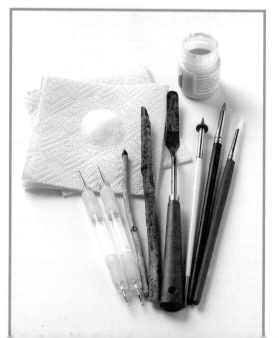

Other equipment

Board A sturdy board is where you lean on and attach the surface for your artwork.

Water pot These are used both for wetting and rinsing out brushes.

Putty eraser This can be shaped for lifting pencil lines.

Masking tape This will secure your paper to the board, and ensure a clean edge around the finished painting.

Propelling pencil A standard HB propelling pencil is used to achieve a neat and even line drawing from which to work.

Watercolour pencils If you want the lines of the initial drawing to not be visible in the finished piece, these are very useful: the lines will dissolve as you work.

Soap Soap protects the brush when applying any masking fluid.

Handkerchief This is useful for removing masking fluid from your finished piece.

Hair dryer A useful tool to speed up the drying process.

Palette This is used for storing and mixing your paint.

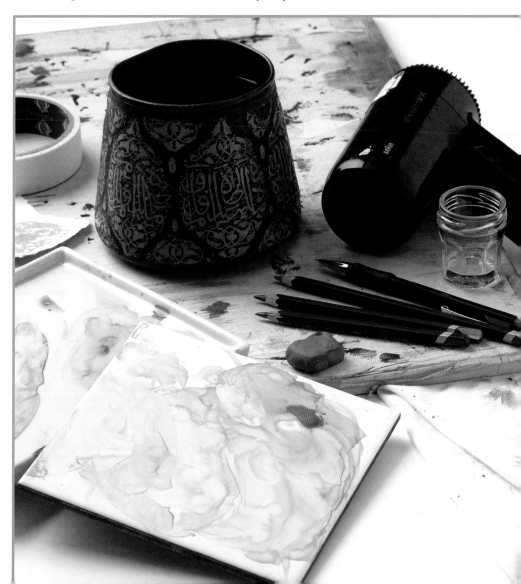

Colour

Use bright colours

Using vibrant watercolours creates clean luminous results. Dark or tertiary colours can easily be produced by mixing two transparent brights together, but a bright colour can never be created from any dull colours. When choosing colours to buy, remember that colours can always be toned down but never brightened up.

A bright yellow placed next to a dark green will leap forwards, whereas a pale creamy yellow would not: without bright colours our paintings can seem flat.

Allow colour to mix on the paper

When bright colours are invited to meet and mix on the paper, they will naturally create a myriad of subtle colour blends, few of which can be achieved by mixing the colours together on a palette.

Consistency

If watercolour is mixed with enough water to enable pigments to move and settle within the fibres of the paper, the results are more exciting than if the paint applied is more viscous. In the latter case, the pigments are unable to move and the result can be less interesting. Many worry about using too much water but I always maintain that as long as the water does not start actually pooling, the wetter you work, the better.

Winsor blue (green shade) was scribbled and flicked on to the paper after which cadmium yellow was flicked on to the wet paint and allowed to naturally merge. The resulting swatch shows how many subtle colour changes occurred in this small area. If you add a third colour, it is virtually impossible to get two swatches that look the same. No amount of mixing on the palette can achieve this.

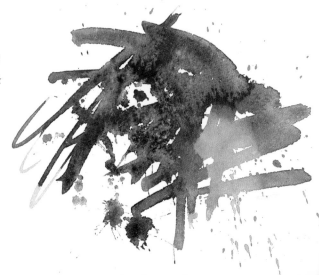

This page shows how various colours interact when allowed to mix on the paper. Try making a colourful mix of paint using your own palette, in order to familiarise yourself with it.

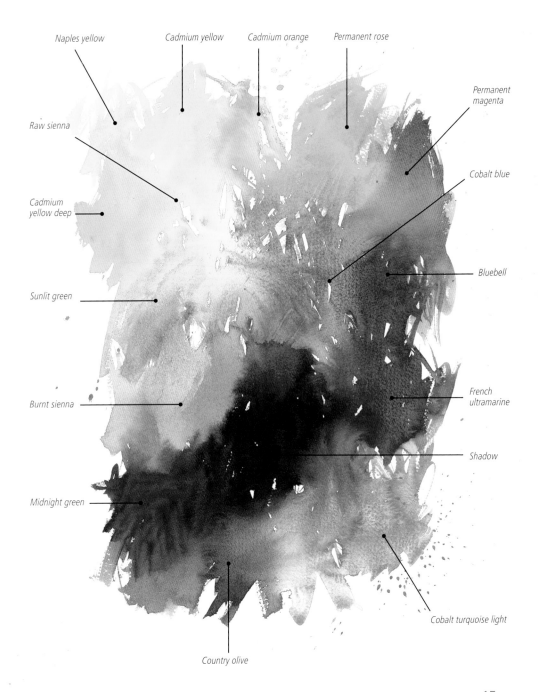

Naples yellow

Cadmium yellow

Cadmium orange

Permanent rose

Permanent magenta

Raw sienna

Cobalt blue

Cadmium yellow deep

Bluebell

Sunlit green

Burnt sienna

French ultramarine

Shadow

Midnight green

Cobalt turquoise light

Country olive

Using a round brush

Most of us have a round brush, and as it is a symmetrical shape it does not matter how we hold it. As long as it feels comfortable it will be correct. Where we hold it, however, will make a difference. To begin with, hold your brush so that your fingers avoid the ferrule or perhaps just touch it. Avoid holding the brush too far down. Let's make a few simple marks on the paper to get the feel of the brush.

Wet strokes on dry paper

Load the brush with any colour you like. Mix the paint on a flat surface such as a kitchen tile, adding water so that the colour is wet and fills the brush. Working on a flat sheet of paper, gently press the tip of the brush on to the paper. Lift it and press it down again nearby. The more pressure you apply, the bigger the blob you create (see right).

Each brush will create its own shape on the paper. By controlling the pressure you apply to the brush you control the shape you create.

The paint will stay exactly where you place it. It will not flow anywhere else. The paint should be wet and glistening on the paper. If you work nice and wet a small dark drying line will be created around each shape once it has dried.

The larger marks, made by applying more pressure, suggest larger petals. The small dark dots were made with light touches of the tip of the round brush.

Paint a series of these small blobs of colour using different colours and you can suggest flowers such as foxgloves or salvia (see far right). Varying the sizes and colours of the blobs suggests various flowers. You can use this technique for negative painting, leaving white paper showing between blobs to suggest flowers such as daisies. Paint a couple of lines and stalks are suggested. Not everything needs to be precise; sometimes a painting is more interesting when some elements are left to the viewer's imagination.

That was easy! Now you have made a start, we can move on to a bouquet of blobs (see near right).

All of the flowers, stems and foliage in this bouquet were made in moments with this basic technique.

It is simplicity itself to suggest flowers and stems with this technique.

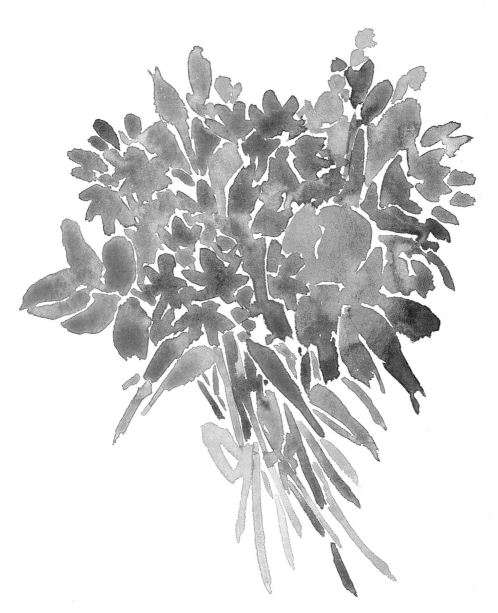

Simple Bouquet
15 x 12cm (6 x 4¾in)
Anyone can make a pretty bouquet like this, even a total beginner. Just be brave and have a go. Any colours can be used for this painting, just make sure you wash the brush out regularly to keep the colour clean. Begin anywhere you wish (I tend to start in the middle and work outwards). Leave little gaps between the shapes, but do not worry if the shapes touch in places, you will become better at leaving small gaps of light as you practise. Continue to use the classic round. I know it is tempting to use a smaller brush, but a brush with a smaller reservoir will be less effective and the shapes too dry.

Controlled shapes on dry paper

Working with the same consistency of paint as before (see page 16), we now gently move the brush to create specific shapes. No details are needed, just concentrate on the shape and the colour.

A plant has a natural line of growth; they are not stiff but have a natural curve, even in an apparently straight stem. Look for example when a small stem branches from a thicker stem, if the stem branches off to the right, the main stem will compensate by curving to the left and vice versa.

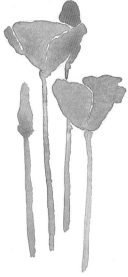

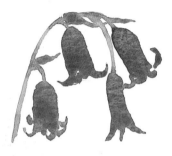

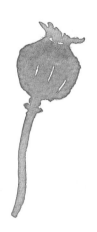

Bluebells
Each bluebell shape is painted separately and the stems added later. If the stems touch the flower heads the blue will run into the green, suggesting they are attached.

Poppy Head
Using a single colour, a clean shape and tiny dry gaps, quite a complex seed head can be suggested.

Californian Poppies
Begin with the poppy in the front and slot the others behind it. Leaving tiny dry gaps of trapped light will suggest the petal shapes. When painting flowers it is important to position each flower directly on the stalk. Think of an imaginary line going up the stalk, this would mark the centre of the flower.

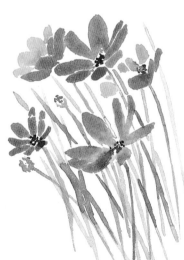

Red Anemones
A mass of flowers and leaves can be suggested by starting at the front and working towards the back, slotting in more and more stalks and grasses.

Opposite
Orchid
14.5 x 20cm (5¾ x 8in)
Orchids, with their crisp, clear shapes, are an ideal choice of subject for this technique. Think of the shapes like jigsaw puzzle pieces. Build up the shapes next to each other and enjoy each colour you use as you employ it.

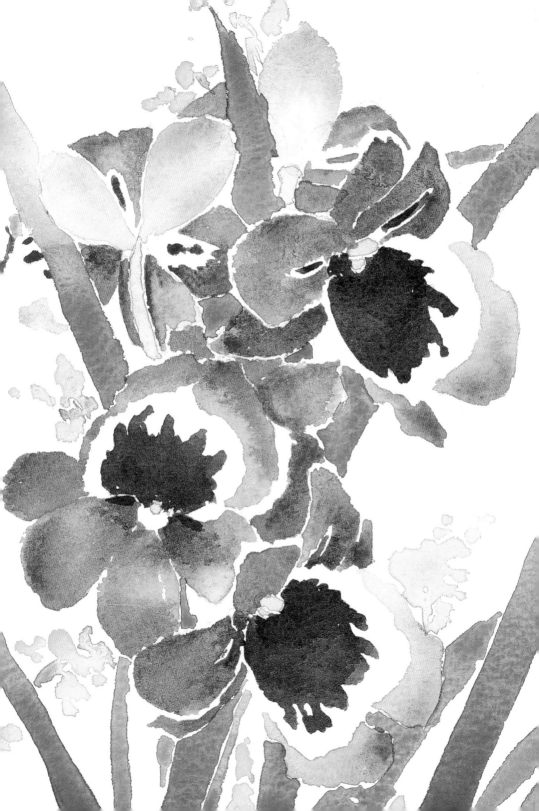

Letting the shapes merge

Once you have tried working on dry paper, the next step is to invite the colours to meet and merge. This is really where the fun starts. This always seems risky in watercolour, but remember that the colours will only run where you let them.

Allowing the colours to touch and merge results in a very painterly effect. The paint needs to be a wet consistency to enable this to work: if the paint dries it is then too late. You can use any colours you choose – invite the colours to merge in places but not all over.

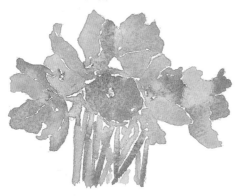

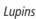

Blown Tulips
Using just a yellow and an orange paint, each of the shapes are painted very wet and the shapes allowed to touch in parts. Some dry gaps are needed to maintain the suggested flower's form. The areas where the shapes touch are called 'lost edges'.
The stems are added whilst the flowers are still wet to allow the flower colours to run into the stalks.

Lupins
Using the same colours as the blown tulips but with smaller, rounder shapes, a totally different flower is suggested. The shapes you create with the brush are important to suggest your chosen subject.

Allium Seeds
Tiny dots of green and raw sienna were placed in a circle, then a ruling pen (you could also use an embossing tool) was used to tease the tiny wet blobs of colour into the centre (see page 30 for the technique) before a stem was added. All of the shapes need to be wet for this to work.
This suggests quite a complex shape. (There is more information on moving paint on page 32.)

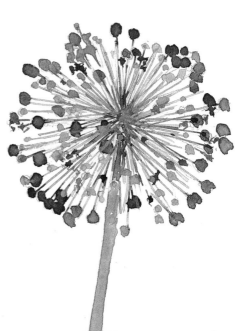

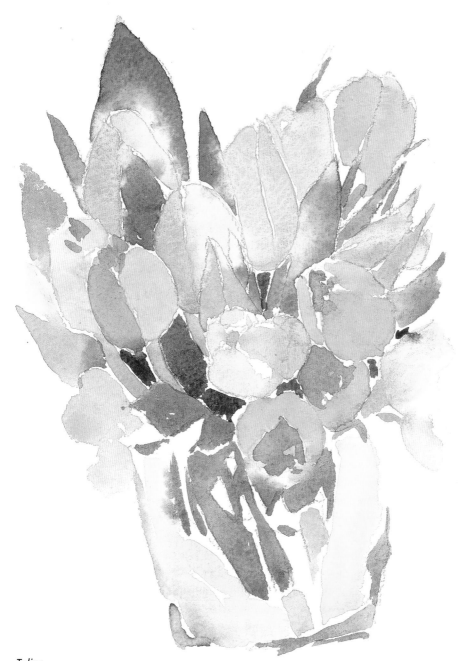

Tulips

16 x 22cm (6¼ x 8¾in)

It is not always necessary to have everything in the picture in focus, nor is it vital that everything needs to be completely in view. In a more complex arrangement, foliage and texture can easily be implied which can in turn emphasise other, more simple, flowers. Watercolour gives the most wonderful effects when it is permitted to merge naturally, so do not poke about at it, just let it move naturally.

Lifting and releasing the brush

Changing the pressure applied to the brush will alter the shape created on the paper. By varying the thickness of each stroke, we can control the shapes we make.

1 Make a simple outline of a lily using a water soluble pencil, then load your classic round brush with permanent rose and touch the tip to the end of one of the petals.

2 Draw the brush down the petal, pressing the heads down until it is almost flat. This will start to give the petal shape and release less colour, creating a lighter tint.

3 Continue drawing the brush down the petal. As the petal narrows once again, begin to lift the brush away and let it form a point. This will release a little more paint from the reservoir in the body of the brush, creating a darker shade.

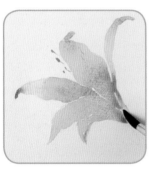

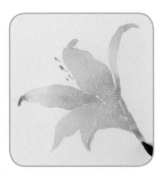

5 While the paint is still wet, rinse your brush and add a little green gold to suggest the stem. Allow to dry.

4 Paint the other petals in the same way, leaving a few gaps and spaces for light, then add a few touches to represent the stamens.

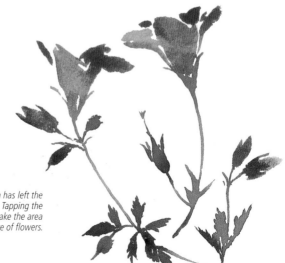

In this example, you can clearly see where the brush has left the paper, as the colour is darkest and wettest here. Tapping the brush at this point will release extra paint and make the area darker; this is the same for even the most delicate of flowers.

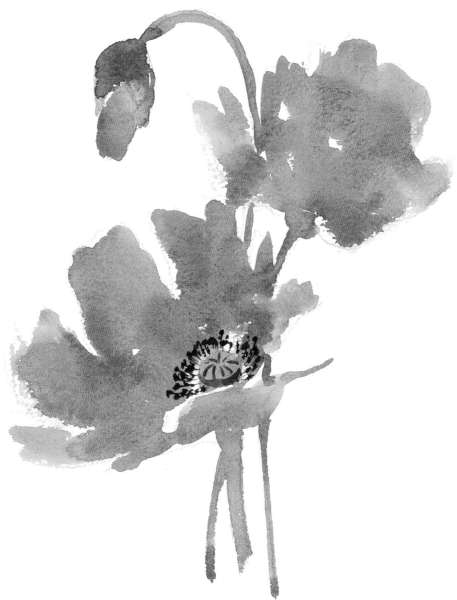

Poppies

Using just three colours, the whole brush is used and the depth of tone created merely by the pressure applied to the brush. Moving the brush along the paper results in a soft tone, lifting it will release pigment and result in a darker tone.

As the brush drags across the paper, a mottled effect can be created that suggests a ragged edge to a petal. This is a lovely technique, so if this happens, enjoy it. Do not be tempted to paint over it to make it 'neat'. This technique relies on you not fiddling with it and allowing the pigments to work for you. Think of it as almost 'moulding' the flowers with your entire brush head.

Double loading the round brush

Double loading a brush enables two colours to mix naturally on the paper. Any two colours can be used but some will, of course, work better together than others.

To double load the brush, the body of the brush holds the main colour – this is usually the lighter colour. The brush is fully loaded, then the tip is placed into a strong colour. The gentler the pressure into the paint, the less of the dark colour will lift on to the brush, the more the pressure, the more colour will go on to the brush. Once the brush stroke is applied to the paper, it is best not to touch it again.

1 Make a simple outline with a water soluble pencil, then fully load your classic brush – not just the tip – with cadmium yellow. Next, dip just the tip into permanent rose.

2 Touch the tip of the brush on the tip of a petal and begin to draw the brush down the petal.

3 As you draw the brush down the petal, add more pressure to flatten the brush.

4 Continue to draw the brush down the petal and lift the brush away.

5 Reload the brush in the same way – there is no need to rinse as almost all of the permanent rose will have been used – then paint the other petals in the same way, leaving a few gaps for light.

6 Rinse the brush and add a stem of country olive while the paint is still wet.

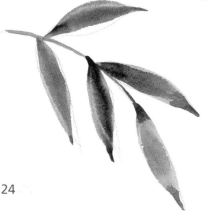

Leaves

This is one of the best exercises for learning brush control. Load the brush with cadmium yellow then touch the tip of the brush into midnight green. Begin with the leaf at the end of the spray: place the tip on to the paper then gently press the brush on to the paper whilst pulling it in the direction of the leaf, then gently lift the brush off the paper. The cadmium yellow will mix with the midnight green naturally on the paper giving a wonderful leaf shape – dark at each tip and down the centre. Attach the stalk then each of the side leaves using the same technique. Reload and double load the brush each time.

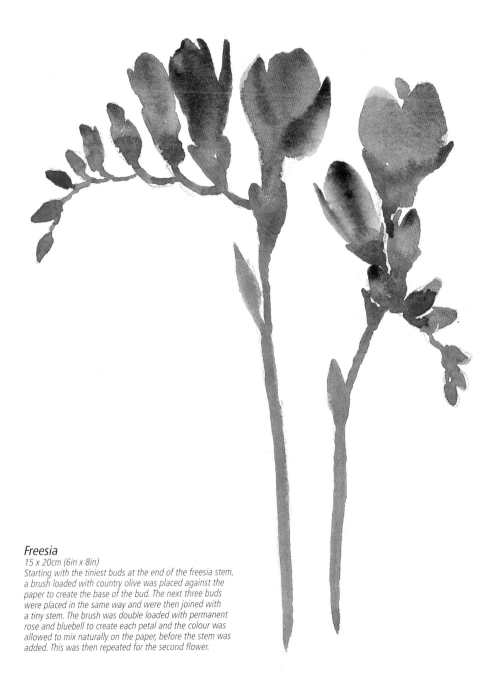

Freesia

15 x 20cm (6in x 8in)
Starting with the tiniest buds at the end of the freesia stem,
a brush loaded with country olive was placed against the
paper to create the base of the bud. The next three buds
were placed in the same way and were then joined with
a tiny stem. The brush was double loaded with permanent
rose and bluebell to create each petal and the colour was
allowed to mix naturally on the paper, before the stem was
added. This was then repeated for the second flower.

Overlaying or glazing

When one layer of paint is laid on to the paper and allowed to dry, and then another transparent layer painted over this, a third colour is created. This has quite a different result than would be achieved by mixing the same two colours together on the palette and applying them. It works in the same way as placing one layer of tissue paper over another. Place a blue sheet over a pink sheet and a mauve sheet is created, but place the same pink sheet over the same blue sheet results in a different mauve.

Colours can be altered or indeed strengthened using this technique. Use a slightly opaque watercolour if you wish to conceal a previously painted colour, use a transparent one if you wish to alter or enhance a previous colour.

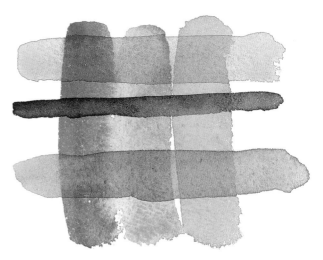

This example shows various colours glazed over the top of one another. The horizontal lines, from top to bottom, are cadmium yellow, indigo and permanent rose. The vertical lines, from left to right, are bluebell, cobalt turquoise light and permanent rose.
Note how the colours interact – transparent colours (such as cadmium yellow) let some of the colour underneath show through, resulting in a third colour. Opaque colours (such as indigo), completely cover the colours beneath. Experiment with your paints to find different effects.

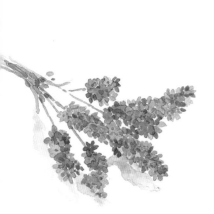

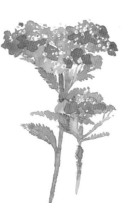

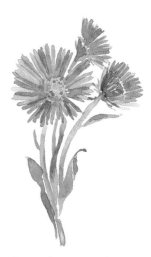

Lavender
Tiny blobs of colour are allowed to dry before more sections are placed on top, this suggests volume and added depth of colour.

Achillea 'Summerwine'
Larger sections are placed on top to suggest a deeper tone.

Erigeron 'Sea Breeze'
More strokes added once the first are dry helps to suggest a mass of petals.

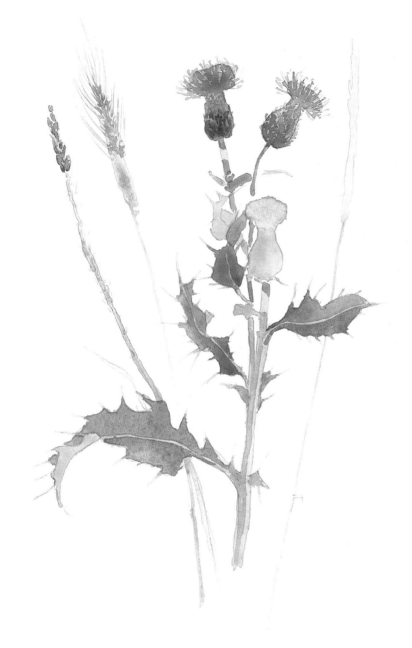

Hedgerow Flowers
14 x 22cm (5½ x 8¼in)
*Using the overlaying or glazing techniques can add depth and form to flowers. Areas
with only the first layer of paint have been deliberately left to show what lies beneath
the finished sections – for example, the lowest thistle head.*
*The first layer of paint can add depth to a subject or indeed add colour; it is the
subsequent layers that add the detail. It can be very difficult to analyse how a painting
is achieved as the first layers are important and create the basis of the painting.*

Spattering

Spattering is a useful way of adding interest and texture to a painting.

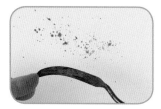 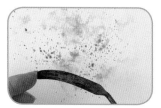

Palette knife on dry paper
Load the palette knife with your colour (permanent rose in this example), hold it over the area and pull the knife back. Move your finger to release the palette knife and it will flick the paint over the paper.

Palette knife on damp paper
Stipple the paper (see page 46) with clean water using a golden leaf brush. While wet, load and flick the palette knife as before for a different effect.

Palette knife on wet paper
Wet the paper with clean water using a golden leaf brush so that it is glistening but not pooling. While wet, load and flick the palette knife as before for a more diffuse effect.

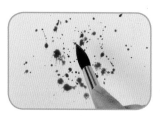 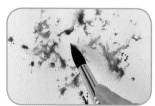 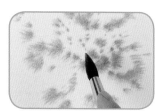

Brush on dry paper
Load the brush with paint; Winsor blue (green shade) was used here. Lift the brush then bring it sharply down to just off the paper, while simultaneously tapping the ferrule with your finger to release the paint.

Brush on damp paper
Stipple the paper (see page 46) with clean water using a golden leaf brush. While wet, load and flick the brush as before for a different effect.

Brush on wet paper
Wet the paper with clean water and a golden leaf brush. While wet, load and flick the brush as before for a diffuse effect.

Poppy
A big brush was used to stipple a wet texture over the surface and the flowers were then painted on the damp paper, allowing colour to run into the tiny wet sections. While this was all still wet, the colour was flicked on to the painting using a palette knife. Spots will stay intact if they land on the dry sections while others will spread into the wet sections. Compare this study of poppies to that on page 23 and notice how much more dynamic this one is. Building up your techniques will make you more creative in your painting.

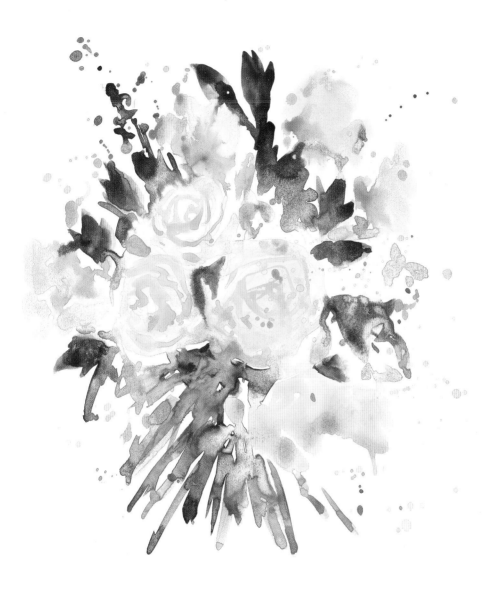

Rose Bouquet

18 x 21cm (7 x 8¼in).
Spattering is used to great effect in this little painting. It implies small, lively flowers
within the bouquet as well as suggesting a looser approach to the subject.
The shapes were placed as wet blobs of colour suggesting flowers and the speckles were
flicked on to the painting throughout the process. Some of these tiny spatters merged
into existing wet colour while those that landed on dry paper remain distinct.

Teasing and bruising

Fine linear marks of paint can be drawn on to the paper using a rounded tool. This is especially useful to suggest stamens or details on petals.

Always use a rounded tool, such as an embossing tool or darning needle, to avoid scraping the surface. The technique will only work with wet paint.

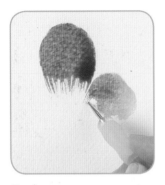 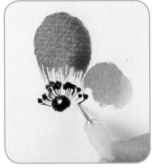

Teasing
Put pressure on the end of any smooth rounded shape with a curved edge – in this instance an embossing tool – and draw it across a wet area. You are aiming to use the object to tease the paint out, but with a light touch so you do not damage the paper. This technique is useful for petals (see left) and fine lines like stamens (right).

Bruising
By adding a little more pressure with a rounded tool against the paper, slightly bruising the paper, a dark line can be created. By using more pressure within a wet shape, you will mark the paper and encourage the paint to pool in the lines you draw.

Purple Anemones
The centres of the flowers were created by teasing the wet paint towards the centre of the flower using a rounded embossing tool. The same technique created the lines on the petals. This can only be achieved whilst the paint is wet. The end of the leaves were teased out using the end of the brush. This is far simpler than using a fine brush and the results are more dynamic.

Opposite
Poppies
13.5 x 22cm (5¼ x 8½in)
This was painted using the same techniques as the poppy on page 28, then the leaves were teased out using the embossing tool. Only very light pressure was used as the paint was scribbled to create texture. The hairs on the stems were suggested by scribbling from side to side using the embossing tool. Directional lines on the petals were suggested using the embossing tool pressed hard to bruise the paper. This results in a more subtle line which is easier to apply than using a brush.

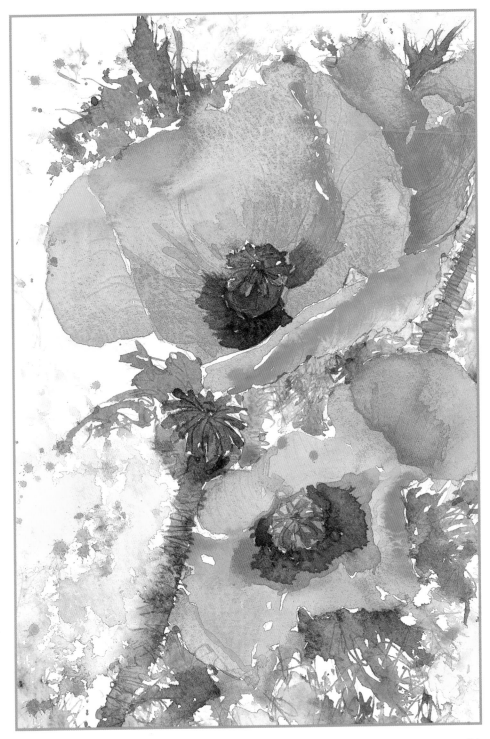

Scraping and moving paint

This is a wonderful technique for moving paint. It uses the handle of a brush rather like a snow plough moves snow, or a window squeegee moves water. The paint is merely moved and a dry channel of lighter colour remains.

Draw the brush firmly over wet paint to leave a scraped-out line of clean paper. Firm pressure using a palette knife or perspex brush handle should not be confused with applying pressure to bruise the paper, which will achieve a dark line. If a dark line is created rather than a light trough of light, adjust the angle of the palette knife and try again.

Grasses can be simply achieved by gently flicking a perspex handled brush or palette knife over the paint, leaving a white line in its path.

Thicker lines or shapes can be achieved by drawing the handle of a perspex-handled brush (or a palette knife), on its side rather than on its end, through the wet paint.

Lupins

The colours were placed in blocks on wet paper to suggest tall flowers. Green was randomly painted at the bottom of the picture, after which a perspex brush handle was used to drag the paint upwards to suggest stems and grasses. Colour was then flicked on to suggest more flowers. Some colour landed between the 'barriers' created by the perspex brush handle in the green area – this flowed along the barrier and created a wonderful sense of movement.

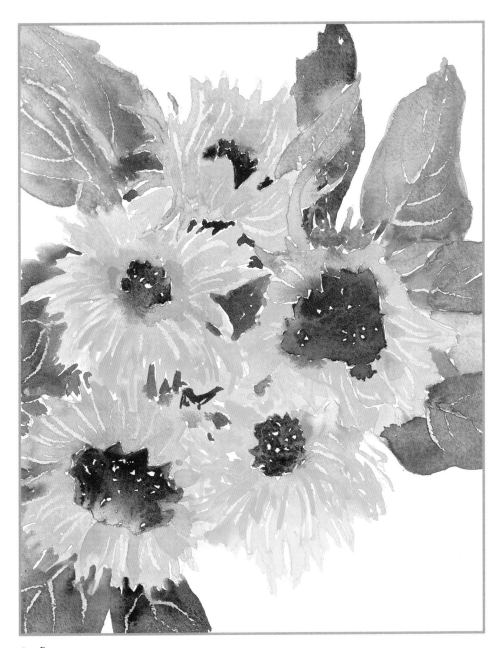

Sunflowers

19.5 x 24.5cm (7¾ x 9¾in)

The dark centres of each of the sunflowers were painted in turn, then petals were added. The petals were encouraged to touch the centres in places, creating controlled runs. Leaves were added while the petals were still wet to enable some colour to run into the leaves. The veins and petal details were then suggested by using the perspex brush handle. Each sunflower was completed separately and attached to its leaves before moving on to the next flower – so the whole painting was done while wet!

Dropping in

For this technique either pigment or water is applied to a wet area of paint and allowed to merge naturally. Usually this is applied using the point of a pointer brush as this allows you to control the amount of liquid going on to the paper.

Drops of pigment touched on to a wet area will run as far as the pigment allows. The longer the brush remains on the paper, the more pigment is released, and the further the colour will travel. Some pigments move further than others so it is worth experimenting with your paints.

Various colours can be dropped on top of each other to either darken or change a section of colour. Water can also be added, which is a great way of lightening areas like petals.

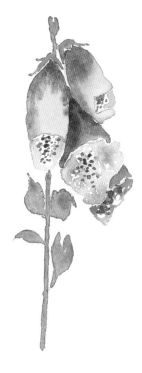

Nasturtium
A deep red was dropped into wet orange paint to create form and direction on the petals. The base colour must not be too wet or the paint will merge and the linear shapes will be lost.

Foxgloves
Here dark red was gently dropped on to the tops of the flower heads to provide the form for the top of the flower. This needs to be very dark and viscous. A more dilute colour was dropped in the insides of the flowers for a more subtle shading effect.

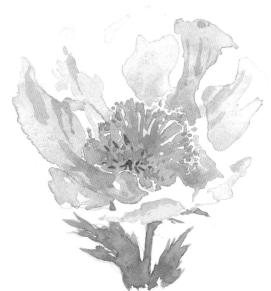

Icelandic Poppy
A lovely glow of light can be added to colours by dropping raw sienna into them. Here raw sienna has been dropped on to a light purple. The advantage of dropping in colour – as opposed to mixing them together beforehand – is that both colours remain visible once you have finished.

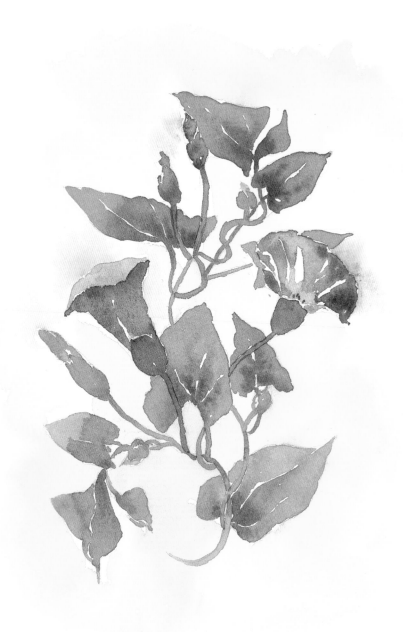

Morning Glory

17 x 23cm (6¾ x 9in)

By dropping Winsor blue (green shade) into the green gold of the leaves, tonal contrasts can be achieved in a single layer of paint, retaining a clean result. Wonderful subtle mixes were formed when cadmium yellow was dropped into the magenta on the flowers. The background was added after the morning glory had dried; very dilute colours were dropped in and allowed to blend on the paper (there is more information on backgrounds on page 52).

Lifting out

This is a wonderful technique used to remove colour entirely, adjust the intensity of colour or create soft areas within a painting.

Lifting out from a dry shape

 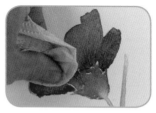 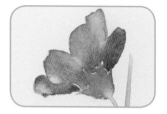

1 Once your painting is bone dry, use a wet classic round brush to gently agitate the area you want to lighten.

2 Press a clean tissue on to the area and lift away.

3 Repeat as much as you wish to create highlights.

Lifting out dappled light

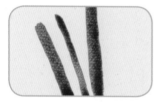 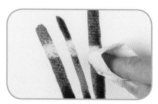

1 While your painting is wet, double up a piece of clean kitchen paper and roll it around your finger

2 Press the wet paint firmly to lift out the paint. You must press firmly to take out most of the paint and ensure that it does not flow back into the space.

3 Repeat as necessary. This technique is great for suggesting dappled sunlight.

Lifting out shapes

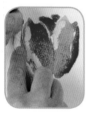 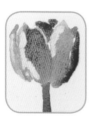

1 While the paint is wet, twist a piece of clean kitchen paper tightly and press it firmly down on to the wet paint.

2 Lift the kitchen paper away to reveal the shapes. This technique allows a greater degree of control than those described above.

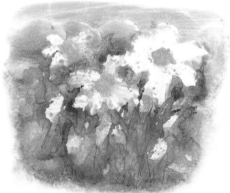

Daisies
This picture was done wet and entirely in one sitting. The smooth paper was wet all over with clean water and a combination of blue and green was quickly applied on top. Immediately the white petals were lifted out using kitchen paper and the centres applied with cadmium yellow deep. The lines were then created using an embossing tool.

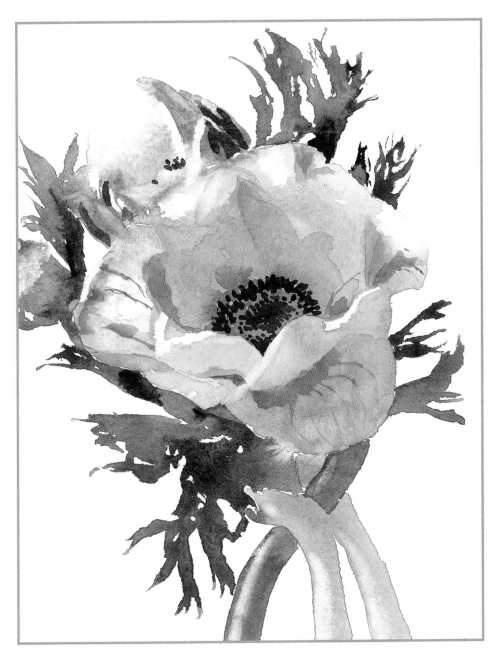

Fresh Anemones

16 x 21cm (6¼ x 8¼in)
The light on the edge of the petals was achieved by lifting out with twisted kitchen paper, whereas the softer highlights on the petals and stems were made by waiting for the painting to dry completely, then wetting the desired section and pressing down firmly with clean kitchen paper. Subtle highlights can be achieved using this technique but success is more likely if staining pigments are avoided.

Combining the techniques

Deciding which techniques to use and when is the challenge in watercolour. Combining techniques is great fun and adds to the visual complexity of the painting, but having too many all together in one painting can be overwhelming, so selecting the right technique for the overall effect is important.

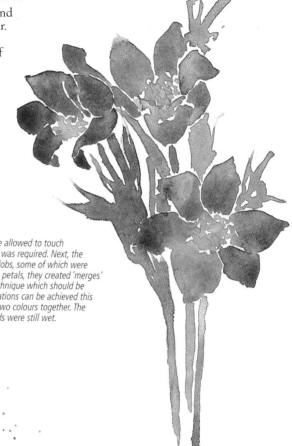

Anemones
The petals were first painted with bluebell and were allowed to touch in parts. The brush was lifted where a darker colour was required. Next, the flower centres were painted using a series of tiny blobs, some of which were allowed to touch. Where the tiny blobs touched the petals, they created 'merges' or 'runs' of paint. This is an exciting watercolour technique which should be celebrated and not feared. Stunning colour combinations can be achieved this way – colours which you can not create by mixing two colours together. The leaves and stalks were added while the flower heads were still wet.

Wild Flowers from the Garden
The main flower shapes were placed on to the paper using cadmium yellow, permanent rose and permanent magenta, then cadmium yellow was flicked into the spaces to add interest. Using country olive and sunlit green, the leaf shapes and flower cases were then added while the previous colours were still wet, so that the colours blended together. Colour was then dropped into the wet areas to intensify the strength.
While still wet, a palette knife was used to move the paint to suggest the stalks. The embossing tool was used to scribble into the tiny wet areas, which helps to suggest a mass of foliage.

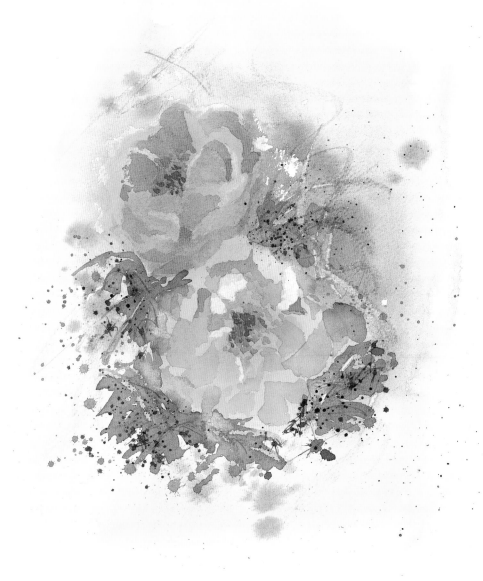

Pink Camellias

The paper was wetted with clean water using the golden leaf brush. The flower and leaf areas were then placed on to the paper using the classic round and permanent rose, Naples yellow and sunlit green. While this was still wet, the colours were intensified, and the light areas were lifted out using kitchen paper. The palette knife was then used to move some of the background colour in order to suggest stalks. As the paper was now drying, more pigment was added to darken sections.

Once dry, darker petals were suggested and the darker foliage was added using country olive. The texture within the foliage was added using the embossing tool and moved with the palette knife. Fresh speckles were flicked on to the green areas using midnight green.

Using an angled brush

Using an asymmetrical brush is quite different from using a round brush. Angular shapes can be created simply and quickly using the entire brush: placing, twisting and turning the brush will produce a variety of shapes ideal for flower painting. The pyramid brush is best suited for this but a short sword brush can also be used.

Scribbling with the point

I call this the scribble technique because it really is as simple as that. Load the brush with any colour – in the example to the left I have used permanent rose deep. Hold the brush vertically and scribble with the point. The brush must be kept upright. More pressure will create bigger marks, a gentle pressure will create tiny lines. Continue to scribble and the lines will merge into one block of colour. Stop when there are sufficient lovely angles and spaces left.

The two darker shapes shown are created by placing single brush strokes on to the previously dried texture.

Pinks

In this example, a similar base of scribbled permanent rose as above was made, with some intentional spaces left. Once dry, the scribble technique was applied to small sections using midnight green. The result gives the impression of complex foliage but it is a very simple technique.

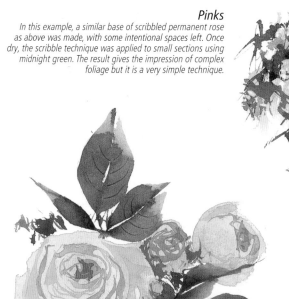

Roses

The base of the roses was applied using dilute cadmium yellow deep and allowed to dry. The leaves were then painted using two brush strokes for each leaf. Once the roses were dry, the tip of the pyramid was used to draw concentric spirals suggesting flower centres. This is probably the simplest method I know of suggesting complex rose centres.

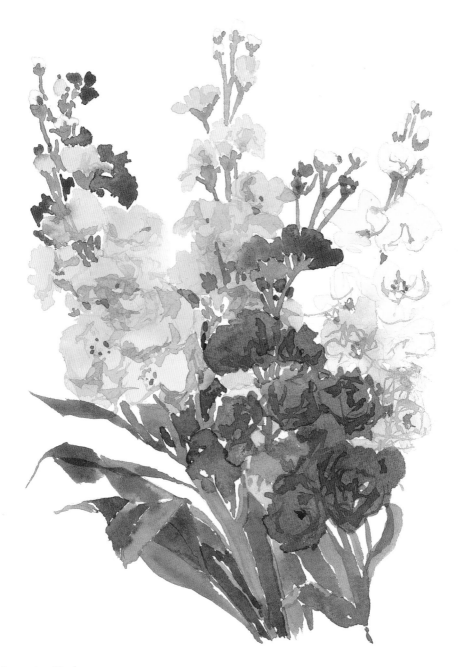

Brompton Stock
19 x 27cm (7½ x 10½in)
The classic round brush was used to create the basic flower and bud shapes while the pyramid brush was used to paint the large leaves and flower details.

Controlled strokes

Controlling the shapes created by the pyramid brush comes with practice, but it is worth mastering as this technique is valuable for the ease with which you can then paint foliage. It is worth really experimenting with these brush strokes to see what other effects you can create.

Rose
Various shapes can be created by placing a loaded brush on to the paper and pivoting the brush on its point to make a curved shape, lifting the pressure to make the shape narrower.

Penstemon
Load the pyramid brush with midnight green then place the brush on to the paper. A natural leaf shape will be formed. Place a series of these to form a fern shape and attach a fine stem using the tip of the brush. Each brush has a unique shape so understanding how pressure affects this shape is crucial.

Bamboo
A bamboo shaped leaf is achieved in exactly the same way by extending the brush stroke on the paper and dragging the brush along backwards.

Compound leaves
Alternate compound leaves are where the leaves grow at right angles to one another and alternate up the stem. For these, the brush is simply placed on to the paper and lifted to leave a perfect leaf shape. The stem is then added using the point of the brush.

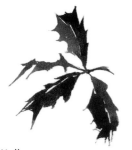

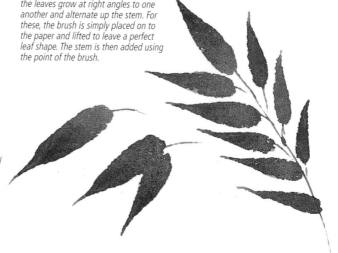

Holly
Holly type leaves are simple to suggest by painting a series of small 'U' shapes then joining them up to form the central vein. This is repeated for the other half of the leaf.

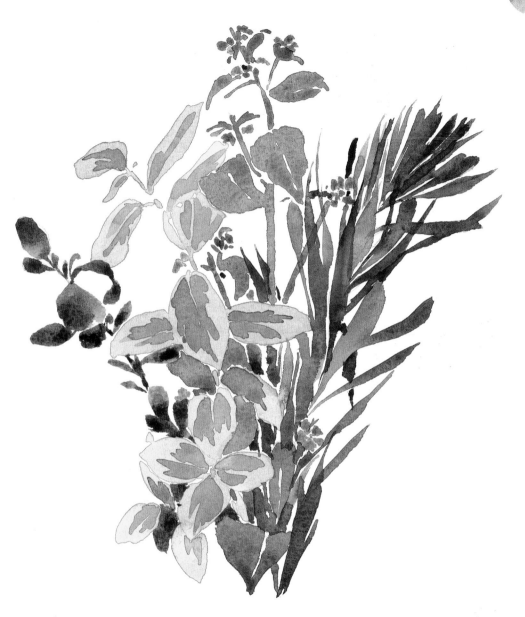

Mixed Leaves
21 x 25cm (8¼ x 9¾in)
It is always easier to paint if the subject is in front of you, and the result will be more convincing. This selection of leaves was picked from the garden, arranged in a pot and copied using the pyramid brush.
Looking at the leaf shapes and combining brush strokes together as well as using contrasting colours and shapes can be a rewarding exercise. I could not resist adding the tiny blue borage flowers.

Double loading the angled brush

Allowing the colours to mix naturally within the brush and then applying them to the paper is a wonderfully dynamic way of painting using watercolour. It can be compared with drawing or sculpting with the brush.

Petals with the double loaded angled brush

1 Load the pyramid brush fully with French ultramarine, then load only the tip with permanent rose and draw it over the paper. Vary the angle and pressure on the brush to release different amounts of the colours.

2 Repeat the process from the central point, drawing the brush away and gradually releasing the pressure so that the tip allows you to create sharp points.

The lower left petal was painted with a brush loaded with a single colour. Compare the colour of the petal with the others to see how this technique helps to avoid a flat effect and add interest.

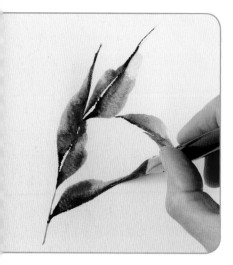

Foliage with the double loaded angled brush

For this example, the body of the pyramid brush has been loaded with sunlit green, and the tip with country olive. This brush allows you more control for longer lines than the classic round.

The dark colour in the tip gives a strong, sharp directional, while the belly of the brush gives a natural dynamic shape. Together, the two colours blend on the paper naturally, making the work fast and very effective.

Opposite
Blue Iris
22 x 32cm (8¾ x 12½in)
Allowing two bright colours to mix naturally in the brush as well as the paper gives fabulous results. Think of it as if you are moulding or sculpting your subject with the pyramid brush: lifting to create a small shape and pressing the whole brush on to the paper to get a broader stroke. This is a much freer approach to painting. It is essential that the shapes created with this technique are not tampered with but that the colour is allowed to mix naturally on the paper. Dark lines are applied using the embossing tool, while light ones are applied using the palette knife or the handle of a perspex brush.

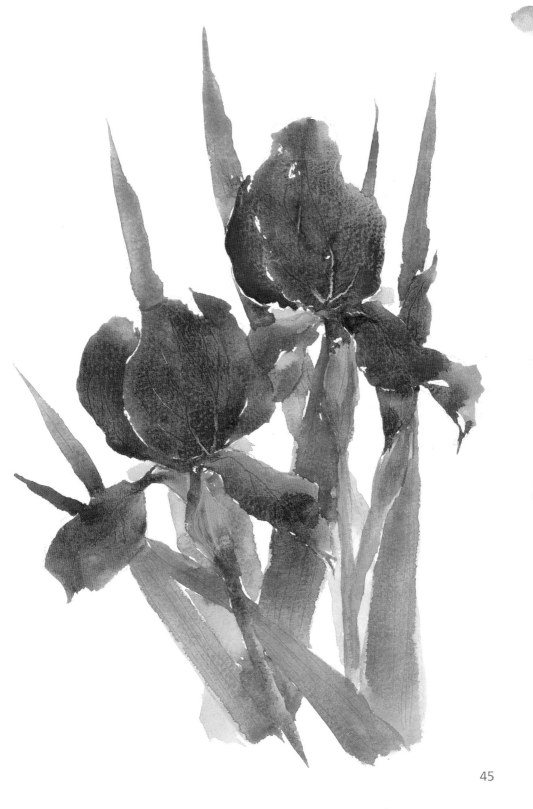

Using a stippling brush

The stippling brush is fantastic for creating texture within a painting. By 'texture', I simply mean how we suggest the different feel of various objects and how we can suggest this when painting. This is one of the simplest yet one of the most useful techniques. Water can be applied to the paper as well as colour, allowing a huge range of textural opportunities to be achieved.

Light stippling
Plunge the stippler brush into water and squeeze out the excess. This prevents the permanent rose paint soaking into the belly when you load it. With the paint just on the tip of the brush, very lightly touch it to the dry paper.

Heavier stippling
Plunge the stippler brush into water and pick up the colour (permanent rose) before tapping the brush lightly on the surface for a different effect.

Multi-stippling
After stippling an area heavily, repeat the process with a different colour on top. This fills in the spaces, which is a great way to create certain flower heads.

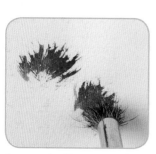

Drawn stippling
Load the brush as for heavier stippling. Starting in the centre, touch the stippler (loaded with a mix of bluebell and permanent rose) to the surface and gently flick outwards from a central point. Repeat to produce a spiky effect suitable for flower centres, or flowers like mimosa or thistles.

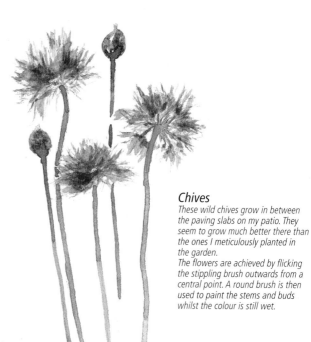

Chives
These wild chives grow in between the paving slabs on my patio. They seem to grow much better there than the ones I meticulously planted in the garden.
The flowers are achieved by flicking the stippling brush outwards from a central point. A round brush is then used to paint the stems and buds whilst the colour is still wet.

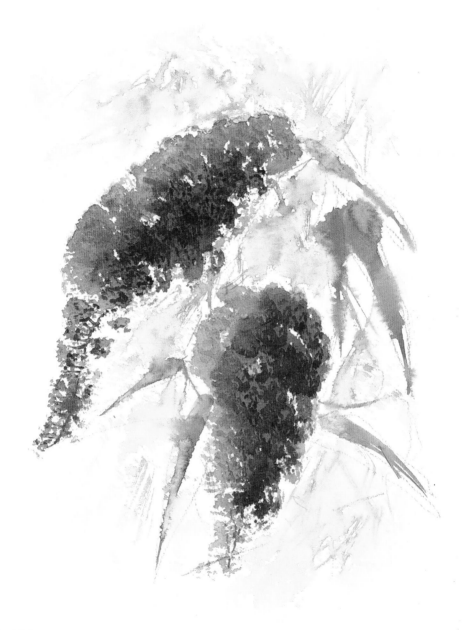

Buddleia
19 x 25cm (7½ x 9¾in)
The flower shapes were stippled on to the dry paper using permanent magenta and a stippling brush. While wet, the background was stippled with water, then the pyramid brush was immediately used to scribble all over the background area with sunlit green to create the most wonderful feeling of dappled light. While the painting was still wet, a darker green mix was used: beginning with the point of each leaf, the brush was dragged backwards, stopping at the flower. This gives the impression that the leaves disappear under or behind the flowers. The darker flower detail was then stippled over the previously dried colour.

Using salt

Using salt on a painting is an exciting technique, the results of which emerge over time as the painting is drying. Used in excess the effects can appear a bit gimmicky but used sparingly it is fabulous to suggest a variety of textures and starburst shapes.

Each grain of salt will create a starburst shape if a cluster of grains settle on the paper. The pigment is absorbed into the salt granules in a larger area, lightening it and creating a dark edge. The painting must be left to dry naturally and the salt permitted to absorb the pigment slowly.

Experiment using different colours, but patient as the effect emerges on drying. Do not be tempted to keep adding salt if it appears not to be working, and remember that darker colours achieve greater contrasts than lighter ones.

In the example above, Winsor blue (green shade) was scribbled on to dampened paper using the pyramid brush then cadmium yellow was flicked on top. While this was still wet, salt grains were sprinkled sparingly on top.
Water can also be flicked or dropped on to the paper whilst the salt is on the surface, adding to the textures created.

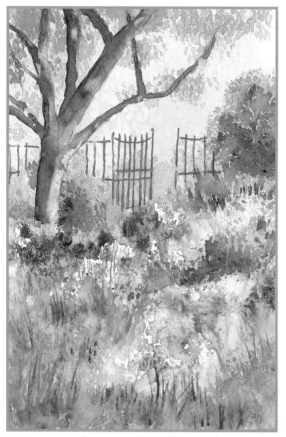

Sunlit Garden
Salt was sprinkled on to the light coloured background creating very subtle, almost ethereal, texture. The salt added to the flower beds adds a more general texture.

Opposite
Coreopsis 'Crème Brûlée'
15 x 23cm (6 x 9in)
If you want to create texture quickly then salt is really effective. The salt needs to be added whilst the colour is still wet – once the sheen has left the paper it is too late.
That said, as long as sections of the painting are wet, the salt can be added. It is better to add salt in small areas while the painting is in progress rather than trying to keep large sections wet.

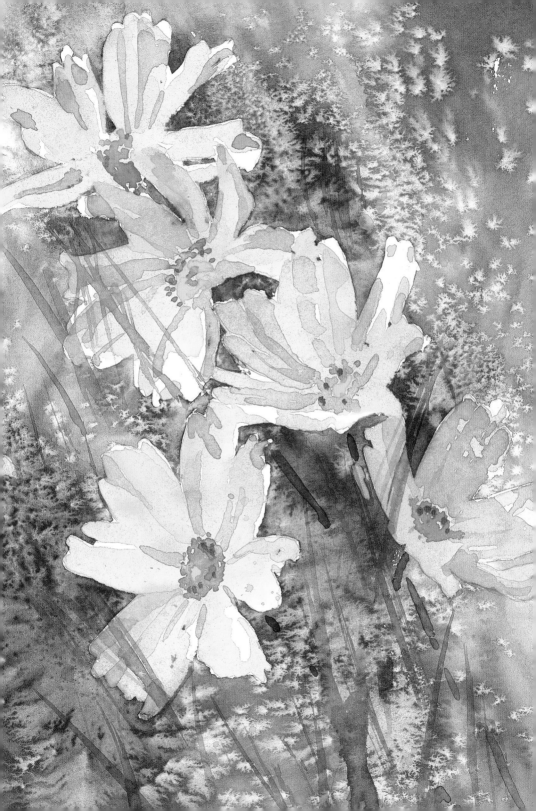

Using masking fluid

Masking fluid is a useful medium that protects the paper from layers of paint and preserves the original white of the paper. It needs to be used accurately for the best results.

As masking fluid dries like a latex layer it will ruin brushes if allowed to dry on them, but it can be applied with embossing tools and wipe-away tools. If using a brush, use a synthetic brush and, before dipping it into the masking fluid, coat it with liquid soap, wipe the excess off the brush, then dip it into the masking fluid. This will protect the brush and will make it easier to clean.

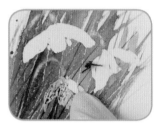

1 Draw your snowdrops using a graphite pencil, then use a synthetic brush to apply masking fluid to areas you wish to remain white or very light. Work as neatly as you can and allow to dry thoroughly. Clean your brush thoroughly as soon as you have finished.

2 Once dry (this should take four or five minutes), paint the leaves and stems using any of the techniques mentioned earlier and allow the paint to dry.

3 Use a fine cotton handkerchief to gently stroke away the masking fluid.

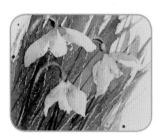

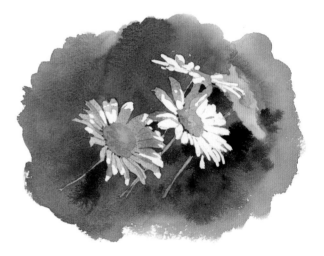

4 With the round brush and dilute French ultramarine, add a little subtle shading to the snowdrops' white flowers.

Daisies

The white parts of the daisy petals were masked and allowed to dry, then the paper was wet with clean water and pale colours dropped over the flower heads. Cadmium yellow deep was dropped into the centres and allowed to merge slightly into the petal areas. Once dry, the dark green background was added, painted straight over any masking and avoiding any petals not masked. Once totally dry, the masking fluid was gently rubbed away.

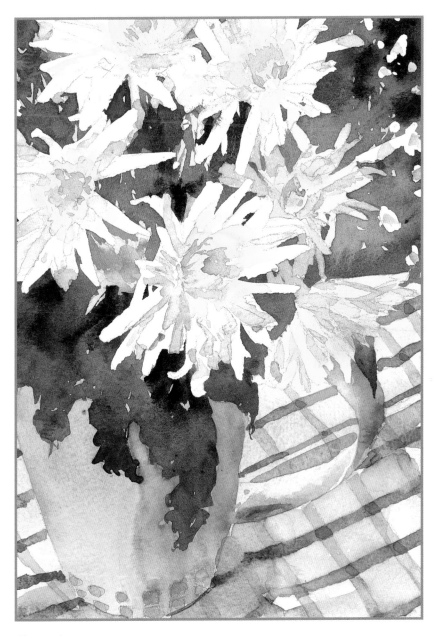

Chrysanthemums

14.5 x 20.5cm (5¾ x 8in)
The unmistakable shapes of these chrysanthemums are ideal for masking. They would be so difficult to avoid and have such intricate shapes that adding masking fluid over the centres ensures the flowers remain recognisable. Midnight green is used to create the sumptuous contrasts in the background foliage.
The flowers could be painted any colour over the white paper, not necessarily left white. This technique can be used for all sorts of complex flower shapes in various colours, not just white.

Backgrounds

Background or vignette?

It is essential to think about the background of a painting at the beginning rather than leave it until the end and have to compromise by adding a background. There are times when a background is not necessary; this is called a vignette, where the background is entirely free of paint. Botanical studies are typically vignettes. Coloured backgrounds are an integral part of the painting process.

Morning Glory
In this example, the background was first wet all over and soft colours dropped on to the wet surface. These colours are the same as used for the painting itself. Once the background had dried, the darker flowers were painted on top.

Pansies
The pansies were completed and once the flowers were completely dry, the background was added. The entire background was wet up to the edges of the flowers, then colour was dropped on top and allowed to merge naturally.

Finishing with a background: leaving space

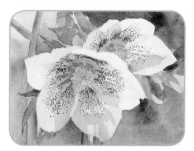

1 Complete your painting of a flower and allow it to dry completely. Start to lay in the background. To avoid a single flat colour, use lighter tints or colours nearer the dark areas. Here I am using sunlit green near the darker stems.

2 Similarly, use darker shades or colours nearer the light areas. Allow the different colours used in the background to bleed into one another for a soft, out-of-focus effect. I am using country olive and indigo near the lightest petals.

Finishing with a background: overlaying

1 Lay in the basic background shapes using wet in wet techniques (such as dropping in on page 34) to create a soft focus image suggesting background flowers and the base of the flowers and allow to dry.

This picture shows an overlay of the shapes I intend to add – note that I have left space in the background where I intend to add leaves to the foreground. As you become more experienced, you can do away with a physical plan and just work from a plan in your head.

2 As you work over the foreground, use stronger colours and more defined strokes to give the impression that these foreground strokes are in focus and closer. Blend the colours between the foreground and background to create a natural midground.

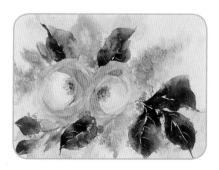

In the finished example, note how some of the softer background leaves remain visible, and the foreground detail on the flowers complements the softer background shapes.

Creating the background as you work

Backgrounds can also be painted at the same time as the foreground. For this approach, the sections need to be wet to allow the paint to flow. This can appear to be quite random, but is actually very controlled.

Planning is essential for this technique, as the flowers and background on which you are working need to be simultaneously wet, although the entire picture need not be wet.

1 Use the classic round brush to stipple indigo as the centre of the flower, and tease out lines with the embossing tool. Double load the brush with French ultramarine and permanent rose and create a few petals.

2 Rinse your brush and use very dilute cobalt turquoise light to work around the wet petals. It is important to leave a line of dry paper.

3 Where you want the colours to blend, simply take the very tip of the brush across the line of dry paper. The wet petal colour will rush into the background. You can then draw the petal colour around the wet background area.

Play around and experiment with controlling the amount of colour that rushes across and with keeping harder edges. This technique is fantastic for combining the best of wet into wet and wet on dry, so it is well worth trying out and enjoying yourself.

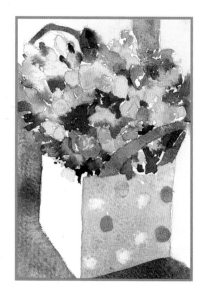

Birthday Box
The flowers on the edge of the composition must be painted at the same time as the adjoining background section. Some would consider it a mistake to let one colour run into an adjacent colour, but this is the beauty of watercolour – it flows so freely and creates gentle effects impossible to achieve any other way.

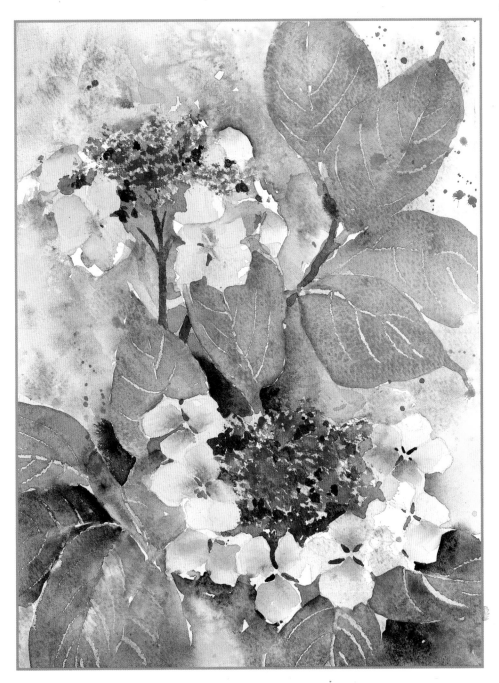

Garden Flower
20 x 26.5cm (7¾ x 10½in)
Various techniques have been used for this painting including stippling, dropping in, scraping out, flicking paint and allowing sections to merge. This has resulted in quite a complex painting.

Jug of Daffodils

The vibrant complementary colours drew me to this springtime subject, which is based on the painting on the first page of this book. Small sections of colour are placed adjacent to each other and invited to touch and merge in places.

You will need
Saunders Waterford HP paper
Brushes: classic round
Paints: cadmium yellow, cadmium scarlet, country olive, Winsor blue (green shade), bluebell, French ultramarine, cobalt turquoise
Low-tack masking tape

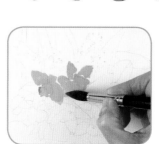

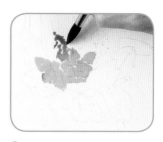

1 Use a 2B propelling pencil to sketch your initial lines on the paper, then border the edges with low-tack masking tape.

2 Double load the classic round brush with cadmium yellow in the body and cadmium scarlet on the tip, and use it to paint the two central daffodils, leaving a few gaps for light.

3 Rinse your brush and pick up a light green mix of country olive and a little cadmium yellow. Use this to make some small foliage marks above the flowers.

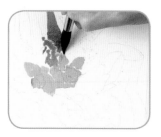

4 Pick up Winsor blue (green shade) to paint the darker part of the leaf above the centre.

5 Rinse the brush and pick up country olive and a little cadmium yellow. Paint the lighter part of the leaf and allow a little of the darker colour to bleed across. Use the same colour to develop some more small marks around the daffodil flowers.

6 Paint a second large leaf as before. Rinse the brush and double load it with cadium scarlet in the body and cadmium yellow on the tip. Use this to paint the first tulip petal.

7 Paint the other tulip petals, touching the brush to the bottom of the wet leaf to let the orangey-red bleed across.

8 Add more of the light green mix in stippled touches to the right of the tulip. While wet, double load a clean brush with cadmium yellow in the body and cadmium scarlet in the tip and use this to paint the tulip petals behind the first.

9 Rinse the brush and paint the shadow in the jug with bluebell, allowing it to touch the tulip and bleed across.

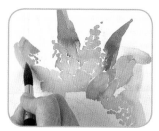

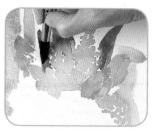

10 Rinse the brush and use clean water to draw the mix across the remainder of the inside of the jug, creating a smooth blended transition. Paint the shadow on the body of the jug with dilute bluebell, allowing the colour of the right-hand foliage to bleed a little across.

11 Paint the tulip on the left-hand side with the same colours as before, but leave a few gaps in the petal as shown above.

12 Use bluebell to lay in the background on the left-hand side. While wet, paint the leaf here with a mix of country olive and Winsor blue (green shade).

13 Paint the background on the right-hand side with bluebell, stippling around the broken foliage and being careful to leave white highlights around that area. Use the same colour to add a sharp edge to the jug.

14 Paint the lower central daffodils with the same colours as before, then pick up country olive without rinsing the brush. Stipple the foliage near the flowers, and overlay the existing foliage with more of the same colour to add depth.

15 Paint the pot with French ultramarine and drop in cobalt turquoise for highlights. If the blue rushes into the yellow daffodil petals, use the lifting out technique to stop it and draw out any excess.

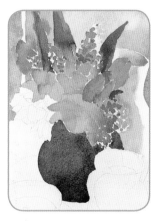

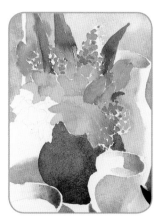

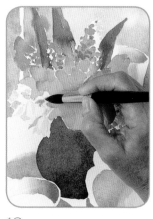

16 Add a little more blue around the foliage on the right-hand side, then use the light green mix to paint the foliage in the top left with a stippling motion. Allow the paint to dry.

17 Use bluebell to place the shadows of the surrounding crockery. Soften the edges of areas to suggest curvature where necessary.

18 Use dilute French ultramarine to paint the shadows of the white flowers on the lower left.

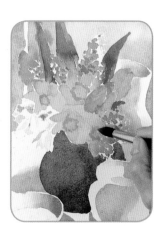

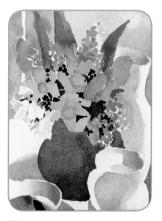

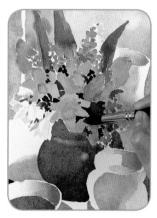

19 Mix cadmium yellow and cadmium scarlet and use this to paint the visible centres of the white flowers and to enhance the daffodils.

20 Use negative painting to suggest the edges of the petals using a dark mix of country olive with a little Winsor blue (green shade). While this area dries, mix cadmium scarlet with a little Winsor blue (green shade) for a tea colour and paint the contents of the teacup.

21 Lift out some highlights on the jug, then glaze the brightest parts of the daffodil petals with pure cadmium yellow.

Opposite
Jug of Daffodils
Allow the painting to dry, then remove the masking tape to finish.

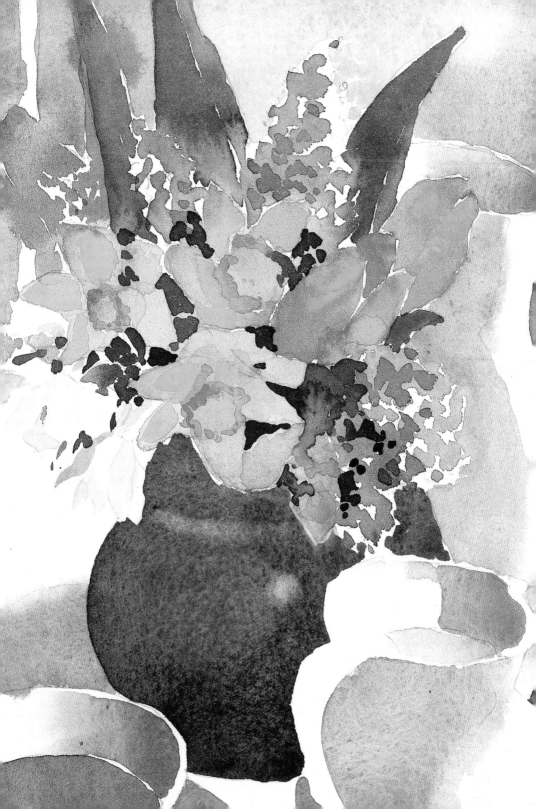

Roses

This is one of the quickest and simplest ways I have discovered for painting realistic roses. Starting with the background and incorporating it into the painting gives the impression of spending far more time on it than is actually needed. Using the golden leaf brush to suggest wet into wet foliage areas adds to the illusion of complexity. Once you master these techniques you will be hooked!

You will need
Bockingford Not paper
Brushes: golden leaf, classic round, pyramid, stippler
Paints: cadmium yellow, opera rose, sunlit green, country olive
2B propelling pencil
Palette knife
Low-tack masking tape

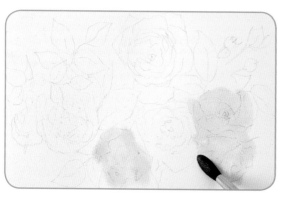

1 Use a 2B propelling pencil to sketch your initial lines on the paper, then border the edges with masking tape. Wet the whole painting with clean water and the golden leaf brush, then use the round brush to drop in cadmium yellow over the yellow roses as shown.

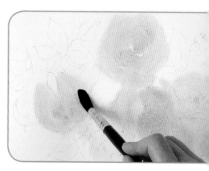

2 Add a little opera rose to the cadmium yellow and drop in the peach roses. If you decide to change your mind, feel free to cover one or two of the yellow roses.

3 Still working wet in wet, establish the green areas by adding sunlit green. Use the brush almost flat and drag it around the paper, so that you can more easily control where the pigment goes.

4 Drop in some more yellow to reinforce the existing yellow areas.

5 With the pyramid brush, add some buds using the cadmium yellow and opera rose both alone and as a mix.

6 Suggest some details to the background and sepals on the buds using the pyramid brush to apply country olive. Allow to dry.

7 Create swirling, quick strokes over the pink roses using the pyramid brush and a slightly deeper mix of cadmium yellow and opera rose. Work outwards from the centre. Touch the brush lightly for tighter lines, and use the body more for broader areas.

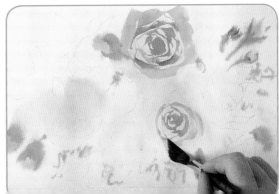

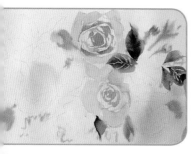 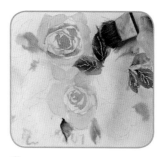 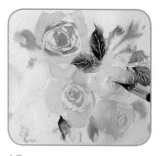

8 Double load the pyramid brush with sunlit green in the body and country olive on the tip, and use this to create some foreground leaves on the right-hand side. Scrape out the veins with a palette knife.

9 While wet, lightly stipple the leaves with a clean golden leaf brush to add texture.

10 Paint the centre of the yellow rose on the right-hand side with the pyramid brush and a lighter mix of opera rose and cadmium yellow, allowing the colour to bleed into the leaves.

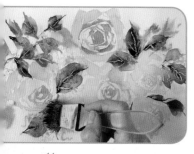

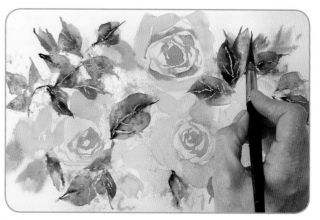

11 Add a few more small green leaves on the right-hand side, then paint the left-hand side of the painting with the techniques and colours used in steps 7–10.

12 Decide if you need to add any more to balance the composition. In this case, I have added two small buds using the techniques and colours above – one on the bottom left, one on the upper right. I also glazed the outer petal on the leftmost rose with a mix of cadmium yellow and opera rose.

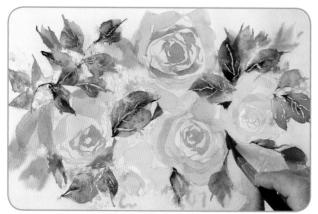

13 Use the pyramid brush to create some small triangular background marks of country olive between the roses.

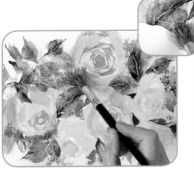

14 Using a semi-circular mask of spare paper to protect some of the edges of the roses (see inset), then use the stippler brush to lightly stipple country olive over the foliage areas. Allow a few touches to overlay some rose petals so that they appear a natural part of the plant.

15 Use the pyramid brush to glaze the outer petals of the yellow roses with a dilute mix of cadmium yellow and opera rose.

Roses

Allow the painting to dry to finish, then remove the masking tape.

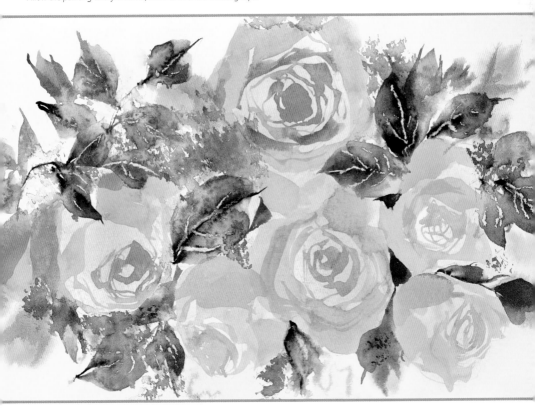

Blue Iris Vignette

There are so many different varieties of iris that you can alter your colours to almost anything you fancy and there will probably be a variety that would look like your painting!

Using the pyramid brush allows you to use an almost sculptural approach to painting the iris, rather than sticking to the constraints of an outline drawing and filling it in. This encourages more creativity and allows the colours to merge together naturally within the shapes created.

You will need

Bockingford Not paper
Brushes: pyramid
Paints: French ultramarine, bluebell, raw sienna, burnt sienna, country olive, shadow
Palette knife
Embossing tool
Derwent Watercolour pencils: crimson lake 20, spectrum blue 32, golden brown 59
Low-tack masking tape

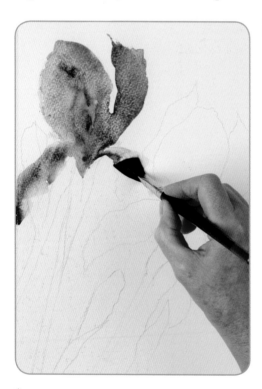

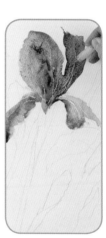

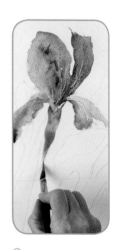

1 Use the watercolour pencils to sketch your initial lines on the paper, then border the edges with masking tape. Double load the brush with dilute French ultramarine in the body and bluebell in the tip. Paint the left-hand iris' petals, starting from the base of each and lifting the brush as you reach the tips.

2 Scrape out light lines to suggest the shape of the petals using the palette knife, then use the embossing tool to create dark lines with the bruising technique.

3 Rinse the brush then double load it with raw sienna in the body and burnt sienna on the tip. Use this to paint the papery case (spathe).

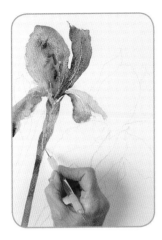

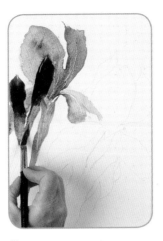

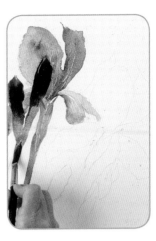

4 Using country olive wet in wet, draw the brush down the stem from the case in one stroke; then use the palette knife and embossing tool to detail the case. Allow the painting to dry before continuing.

5 Mix shadow with bluebell and paint the two buds, then paint the cases as before, working wet in wet. Aim to allow a little of the shadow/bluebell mix to bleed into the cases.

6 Paint the stems as before, using country olive.

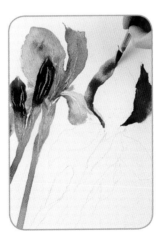

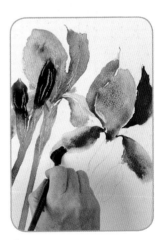

7 Detail the cases and buds with the palette knife and embossing tool, then rinse the brush and pick up raw sienna on the tip. Use this to suggest the stamens.

8 Using a stronger double load of shadow and bluebell, paint the outside petals (standards) on the foreground iris.

9 Paint the central standard with a slightly lighter mix, touching it to the outside standard to allow the colour to bleed at the edges, then paint the lower petals (falls).

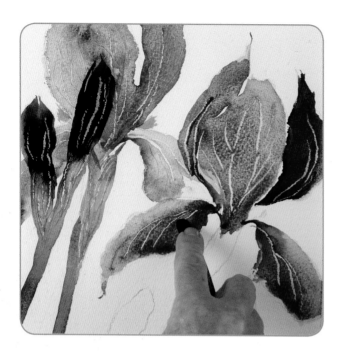

10 Scrape and bruise all of the petals using the embossing tool and palette knife.

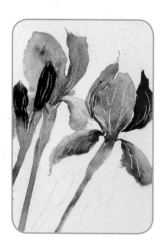

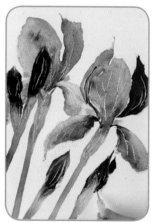

11 Paint the spathe and stem using the colours and techniques in steps 3 and 4.

12 Rinse the brush and touch in the stamens with raw sienna, then paint both foreground buds using the colours and techniques in steps 5 and 6.

Opposite
Blue Iris Vignette
Allow the painting to dry to finish, then remove the masking tape.

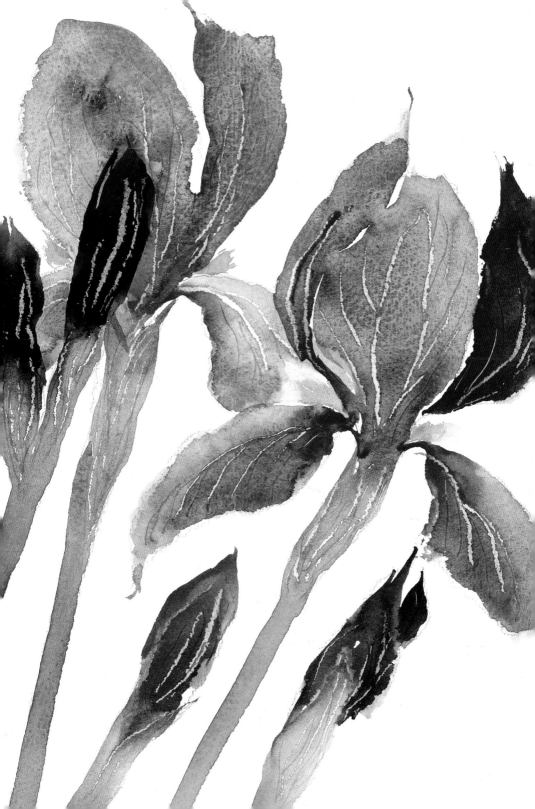

Lilies

Lilies are so incredibly detailed, with patterns and colours so varied, that no matter how yours turns out, no one will be any the wiser if the hues are slightly different or the markings altered.

The scent of lilies can fill a room and the varieties range from tiny miniature blooms to large trumpet-like flowers, so be inspired to buy a bunch and enjoy painting other varieties using these techniques.

You will need

Bockingford Not paper
Brushes: golden leaf, pointer, classic round, pyramid
Paints: cadmium yellow, permanent rose, country olive, French ultramarine
2B propelling pencil
Low-tack masking tape
Salt

1 Use a 2B propelling pencil to sketch your initial lines on the paper, then border the edges with masking tape. Wet the whole paper with the golden leaf brush and clean water. Use the pointer brush to drop in touches of country olive to the tips of the petals. Draw the colour down to the flower centres in curved lines, then take it back up to the tips to lift off.

2 Working quickly, rinse the brush and apply cadmium yellow to the flower centres. Without cleaning the brush, pick up permanent rose on the tip and paint smaller areas within the yellow. Allow to dry completely before continuing.

3 Make a cool mix of French ultramarine and country olive. Apply the mix to the areas of shadow on the petals with the classic round brush.

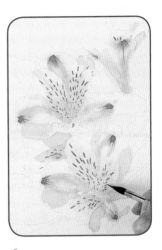

4 Rinse the brush and reinforce the brighter yellow areas with cadmium yellow. Do the same with country olive on the tips of the petals.

5 While the country olive is wet, use the pointer brush to draw out fine details that suggest the shape of the petals.

6 Make a strong orangey-red from permanent rose and cadmium yellow. Mute it with a tiny touch of French ultramarine and use the pointer brush to paint in the details on the lily petals.

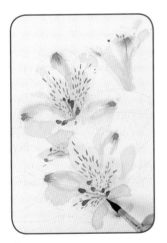

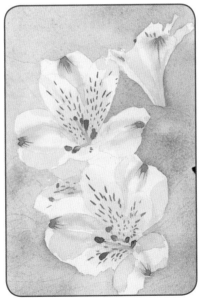

7 Pick up country olive on the pointer brush and paint the stamens, then pick up very dilute permanent rose and paint the carpels.

8 Allow the painting to dry completely, then wet the background with the golden leaf brush. Use the classic round brush to lay in country olive, being careful to keep the edges of the the lilies intact.

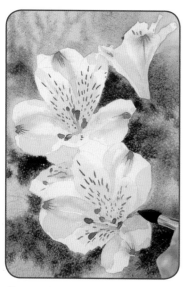

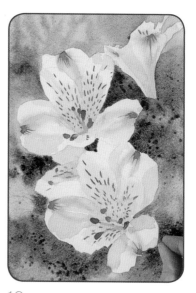

9 Working wet in wet, drop in country olive and French ultramarine to the background. Vary the application; a few scribbled marks will diffuse and add interest. Keep the upper part of the background lighter, and leave a few light gaps in the lower part.

10 Sprinkle a tiny amount of salt lightly over the darkest areas and allow to dry thoroughly. I took the opportunity to touch in a few missed green spots at this point.

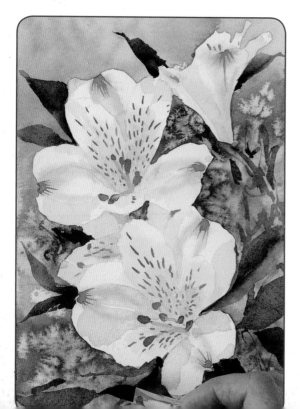

11 Once completely dry, double load the pyramid brush with country olive in the body and French ultramarine on the tip. Use this to suggest stems and leaves in the background, avoiding the areas where the salt effect has been particularly effective.

Opposite
Lilies
Allow the painting to dry to finish, then remove the masking tape.

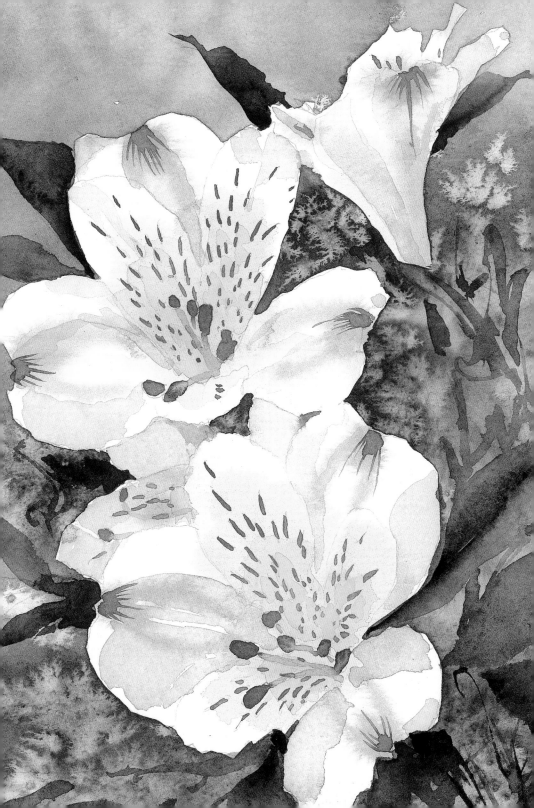

Roses and Buddleia

Roses can flower all summer long, and arranging them with buddleia is a lovely combination. The contrasts between the texture of the buddleia, the curves of the rose petals and the crisp leaf shapes make for a great painting subject.

Use masking tape to create a small frame and have a go at creating some lovely cards using smaller compositions, or crop small sections that you find particularly appealing. Have a go at different coloured roses and perhaps white lilac instead of buddleia. You will be hooked all summer painting these!

You will need

Bockingford Not paper
Brushes: golden leaf, pyramid, stippler
Paints: opera rose, bluebell, cobalt blue, sunlit green, country olive, midnight green, burnt sienna
2B propelling pencil
Palette knife
Spare watercolour paper
Low-tack masking tape

1 Use a 2B propelling pencil to sketch your initial lines on the paper, then border the edges with masking tape. Use the golden leaf brush to wet the whole paper with clean water.

2 Use opera rose to suggest the background part of the roses, applying the paint with quick strokes of the pyramid brush. Use the stippler to apply a mix of bluebell and cobalt blue to areas, and then use the golden leaf brush to paint the background with sunlit green.

3 Work quickly with the pyramid brush and country olive to paint a little detail on the buds wet in wet. Use a mix of sunlit green and country olive to add some leaves with a clean pyramid brush, allowing them to soften into the background.

5 Use midnight green with the pyramid brush to paint in a leaf, then scrape out some detail with a palette knife.

4 Once dry, use opera rose to start to develop some structure on the roses. While you work, use the stippler to stipple some detail on the buddleia with a mix of bluebell and opera rose.

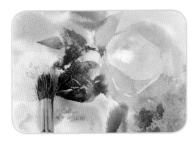

6 Lightly stipple the leaf with a damp golden leaf brush and diffuse it a little, then stipple the nearby buddleia with bluebell and opera rose.

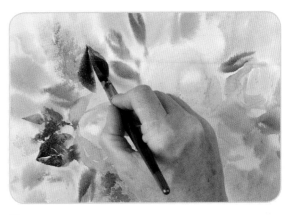

7 Stipple the buddleia above the left-hand rose with the mix of opera rose and bluebell, then use the midnight green with the pyramid brush to lay in a leaf next to it.

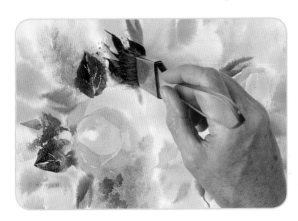

8 Scrape out the leaf with the palette knife, then use midnight green to reinforce the green around the buds. Use the same colour to lightly stipple the area with the golden leaf brush.

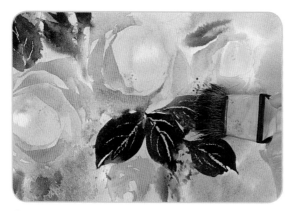

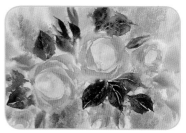

9 Create some fresh opera rose areas on the central rose with the pyramid brush, then rinse and double load it with country olive in the body and midnight green on the tip. Use this to paint in the central leaves, letting them bleed into the rose. Scrape out some details as before, and stipple using a clean golden leaf brush to diffuse and break up the new leaves.

10 Develop the rest of the painting using these techniques and allow to dry completely.

11 Tear a semi-circle from a piece of spare paper to make a mask. Pick up a mix of opera rose and burnt sienna on the stippler and stipple the centre of the roses, using the semicircular mask to protect the closest petals. Pick up some bluebell on the end of the stippler and repeat the process, darkening the appearance in the very centre.

12 Use the semi-circle torn from the paper as a separate mask, and use it to protect the flowers while you stipple country olive around them.

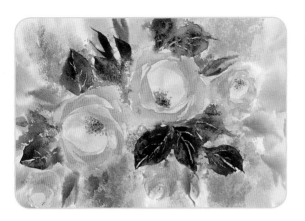

13 Add some very light stippling around the picture with a mix of opera rose and burnt sienna.

Roses and Buddleia
Allow the painting to dry to finish, then remove the masking tape.

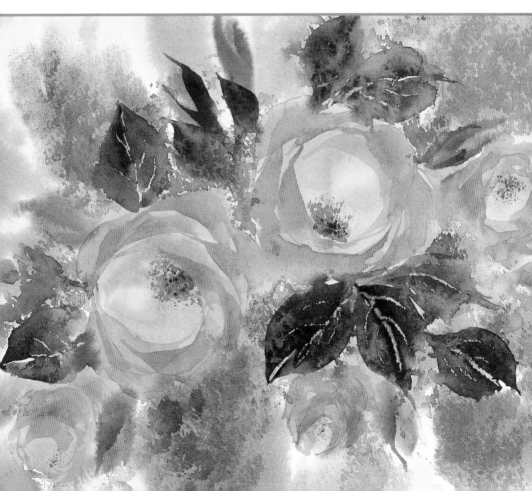

Rose Posy

If I am given a bouquet of flowers I always want to paint it. There is something so sumptuously beautiful about delicate arrangements with gypsophila speckled throughout that changes a bunch of flowers into a bouquet. Once you have mastered the simple technique of using masking, you will want to add gypsophila to all sorts of flower arrangements!

You will need

Bockingford Not paper
Brushes: golden leaf, classic round, pyramid
Paints: Naples yellow, permanent rose, country olive, Winsor blue (green shade), sunlit green, cobalt blue, cadmium yellow
Masking fluid and brush
Salt
2B propelling pencil
Low-tack masking tape

1 Use a 2B propelling pencil to sketch your initial lines on the paper, then border the edges with masking tape. Use a masking brush to apply masking fluid to the gypsophila and other areas shown. Once dry, wet the surface using the golden leaf brush and clean water.

2 Use the classic round brush to drop in Naples yellow on the freesias, daisy and roses, and then drop in permanent rose on the roses wet in wet. Hold the brush quite far up the handle, as this will help give you a lighter touch.

3 Rinse the brush and then pick up country olive and Winsor blue (green shade). Use this to cover the area of gypsophila. Allow it to flow a little way, but not too far. Achieve this by not loading the brush too far, and using the paint fairly strong.

4 Rinse the brush and paint the leaves and stalks in the centre with sunlit green, allowing the darker greens to bleed into these areas fairly freely.

5 Lightly sprinkle a few grains of salt over the dark green area in the centre of the picture.

6 Pick up some fairly dilute permanent rose and cobalt blue and add a slightly uneven background, working it around the edges of your sketch, avoiding the flowers but working over the leaves. The paper will have dried a little by this point, but should still bleed a little. Allow the painting to dry.

7 Rinse the round brush, pick up Naples yellow on it and paint the twine. The background should seep in a little and merge beautifully. Allow to dry thoroughly.

8 Very gently brush your fingers over the paper to loosen the salt, then blow it away. It is important that you do not rub the surface, as you will take off the masking fluid. Use a damp brush to lift out any colour that you feel has seeped too far on to the light areas.

9 Make any small adjustments to the background; I have added a hint of colour to the small rose using the round brush and permanent rose. Next, pick up stronger permanent rose on the pyramid brush and use the tip of the brush to create some implied detail over the pink flowers.

77

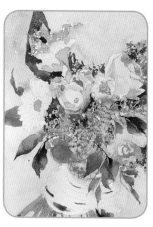
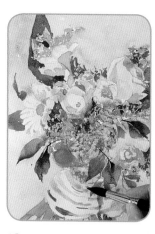

10 Add a touch of country olive to Naples yellow, and add the shadows underneath the freesias and the daisy centre with the round brush.

11 Double load the pyramid brush with sunlit green in the body and country olive on the tip. Pick out the darker leaves as shown, then use the tip to scribble delicately over the gypsophila area, avoiding the salted areas and retaining the shape of the flowers. Add some definition to the stalks with the same brush and colours.

12 Pick up permanent rose and a little cobalt blue on the round brush and create some subtle shadows on the daisy.

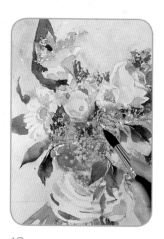
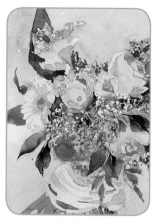

13 Switch to the classic round brush and add some touches of cadmium yellow around the daisy centre and a cadmium yellow glaze on the freesias. Next, spatter any remaining paint on the brush over the centre.

14 Once dry, gently remove the masking fluid. Add a subtle glaze of sunlit green over the gypsophila stems, and touches of the same colour in the flower centres; then remove the masking tape to finish.

Opposite
Rose Posy
Allow the painting to dry to finish, then remove the masking tape.

Sunflowers

Sunflowers are so strong and bold that a dramatic, vibrant, painting technique seems ideal. Scraping and moving the paint achieves some dynamic results very much in keeping with these powerful flowers, while the stripes on the vase echo the use of lines within the composition. Have fun with this one and let the paint go!

You will need

Bockingford Not paper
Brushes: classic round
Paints: shadow, cadmium yellow, cadmium yellow deep, cadmium orange, cobalt turquoise light, French ultramarine
Derwent Watercolour pencils: spectrum blue 32, golden brown 59
Low-tack masking tape
Palette knife

1 Use the watercolour pencils to sketch your initial lines on the paper, then border the edges with masking tape. Leaving a few white spaces, paint both flower centres with shadow and the classic round.

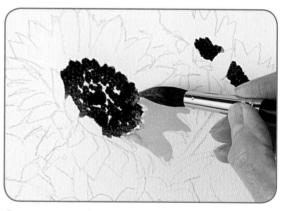

2 Working quickly, rinse the brush and double load it with cadmium yellow in the body and cadmium yellow deep on the tip. Working wet in wet, paint the petals, leaving a small gap between the centre and the petals. Once painted, touch the brush to the gap, allowing the colours to bleed across.

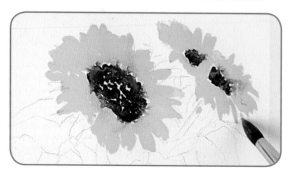

3 Repeat across the remaining petals of the sunflowers.

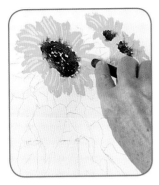

4 Use the palette knife to scrape out some lines, radiating from the centre to suggest the individual petals.

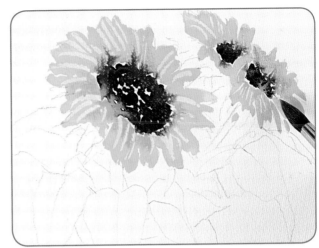

5 Drop in cadmium orange near the bases of the petals.

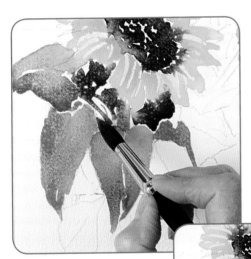

6 Rinse the brush then pick up cobalt turquoise light and cadmium yellow on the classic round. Use this to begin painting the leaves and stems on the left-hand side. Allow the colour to touch the yellows so the colours bleed into each other a little, and add a little shadow for the darker areas beneath the flower heads.

7 While the leaves are wet, scrape out some details with the palette knife to add shape to the leaves.

8 Repeat the process on the leaves and stems on the right-hand side of the painting.

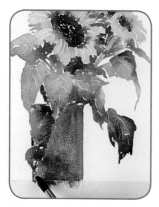

9 Still using the classic round brush, paint in the leaf on the pot as before, then while it is wet, use strong French ultramarine to paint the pot itself.

10 Use the palette knife to scrape vertical lines into the pot. At this point, you can spatter some cadmium yellow over the painting to finish, or carry on with the background steps below.

11 Use dilute French ultramarine to begin to paint the background on the left-hand side; allowing the final leaf to bleed into the background.

12 Paint the rest of the background in the same way, using less and less paint towards the bottom. If you have worked quickly, you can achieve some lovely merging and blending with the flower and leaves on the left-hand side.

13 Spatter a few dilute cadmium yellow spots around the edges then allow to dry.

Opposite
Sunflowers
Allow the painting to dry to finish, then remove the masking tape.

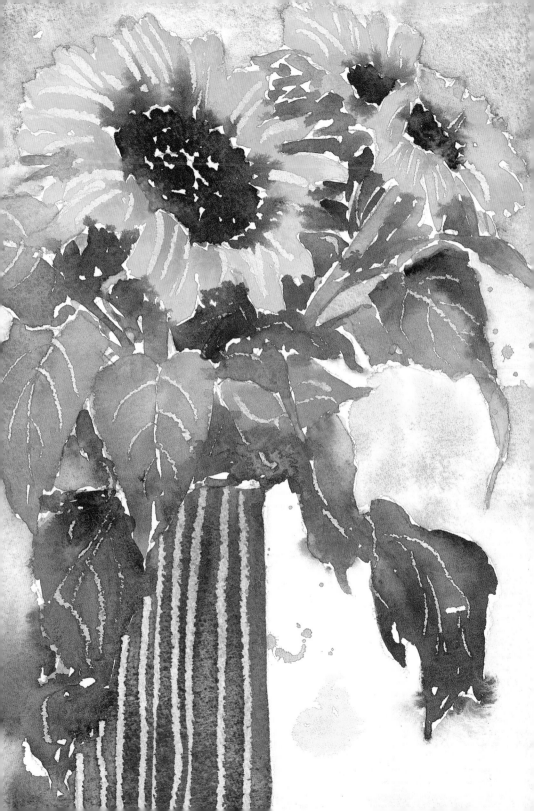

Brompton Stock

What a romantic painting this is! It reminds me of warm summer days and sunshine. Brompton stock has a delightful sweet scent which you can almost imagine in the air as the bicycle bobs up and down on a cobbled road. The techniques are all relatively simple and quick, the flowers feature on page 41, so avoid fiddling too much and leave lots to the viewer's imagination.

You will need

Bockingford Not paper
Brushes: golden leaf, classic round, pyramid
Paints: opera rose, purple madder, Naples yellow, sunlit green, country olive, bluebell, midnight green
2B propelling pencil
Low-tack masking tape
Masking fluid and brush

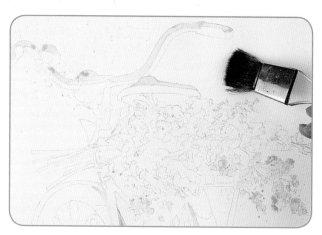

1 Use a 2B propelling pencil to sketch your initial lines on the paper, then border the edges with masking tape. Use a masking fluid brush to apply masking fluid to the areas shown. Spatter a few spots near the bottom, exactly as you would as though spattering paint. Once dry, wet the surface using the golden leaf brush and clean water.

2 Use the round brush to drop in opera rose and purple madder over the stocks. Apply a mix of Naples yellow with a touch of sunlit green to areas where leaves are.

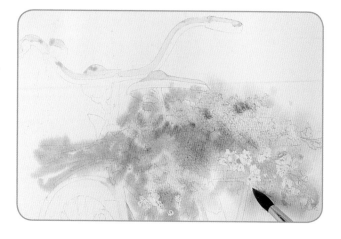

84

3 Add more sunlit green to the mix and paint over the whole background, then drop in country olive in darker areas such as the top right-hand corner. Aim for a blotchy, broken effect; you are trying to achieve an out-of-focus effect. Spatter a few touches here and there for interest. Allow to dry thoroughly.

4 Use the classic round brush to wet around the shapes of the flowers on the right-hand side, then use the golden leaf brush to wet the top of the painting. Pick up country olive on the classic round and create the edge of the flowers with negative painting, drawing the paint up and away from them into the wet background. Use touches of the same colour to add gaps and leaves in the mass of flowers.

5 Wet the lower right-hand side, working around the flowers as before, then drop in country olive to darken the area. Repeat the process on the lower left-hand side around the stems.

6 Paint all of the dark parts of the bicycle with a glaze of bluebell. Where this overlays the green, it will appear very dark; but do not worry – since the bicycle is just a background prop, it is best left slightly variegated.

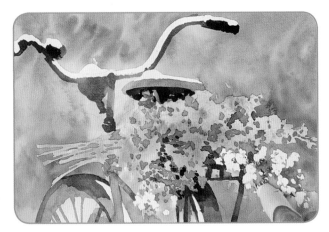

7 Once dry, add another glazing layer to darken the bicycle further under
the saddle and other particularly shaded areas. Once dry, gently remove the
masking fluid.

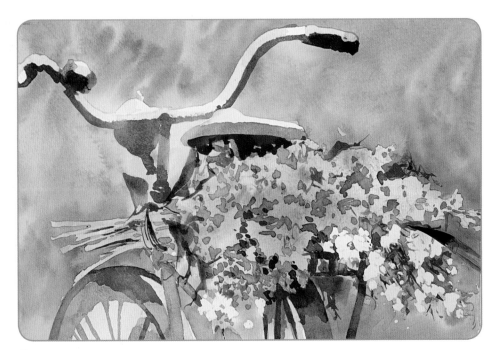

8 Soften the white parts of the bicycle with a very dilute wash of bluebell.
Swap to the pyramid brush and use midnight green to suggest the twine and
leaves around the stems of the stocks. Use the very tip of the brush to 'scribble'
details around the flowers.

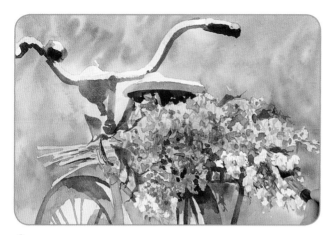

9 Rinse the pyramid brush and use a mix of opera rose and purple madder to scribble details over the lower part of the flowers, to suggest the detail in shadow.

Brompton Stock
Allow the painting to dry to finish, then remove the masking tape.

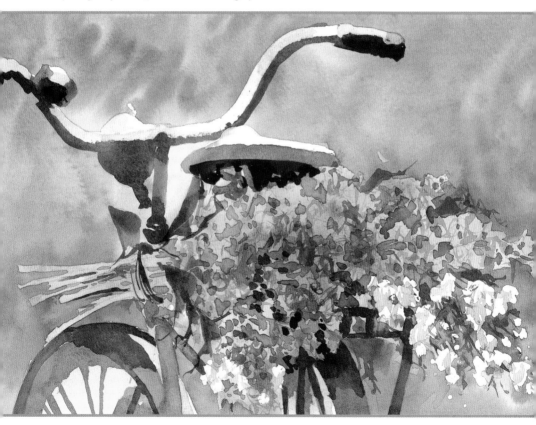

Window Flowers

The techniques in this little project can be used as the basis for all sorts of garden projects, from flowers in watering cans and pots, to pathways lined with flower borders. Tackle the flowers in the same way and the ideas for future paintings are limited only by your imagination.

Suggesting complex, full flower boxes is made so simple using these stippling techniques, and the whole flower effects are done in minutes using the stippler brush.

You will need

Bockingford Not paper
Brushes: stippler, classic round
Paints: bluebell, raw sienna, opera rose, cadmium yellow, permanent rose, sunlit green, country olive
Masking fluid, ruling pen and brush
2B propelling pencil
Scrap paper

1 Use a 2B propelling pencil to sketch your initial lines on the paper, then border the edges with masking tape. Use a ruling pen to apply masking fluid to the window leading and hanging basket cords, and a masking fluid brush to apply it to the flowers as shown.

2 Once dry, use the stippler brush to heavily stipple a mix of bluebell and raw sienna over the left-hand side of the wall. Use a spare piece of paper to protect the straight lines of the central window from the stippling. While the paint is still wet, lightly stipple some pure raw sienna into the sections as you work.

3 Repeat the process over the rest of the background wall and the shadow beneath the windowbox. Aim for a mottled edge to the flowers, but keep the window edge straight.

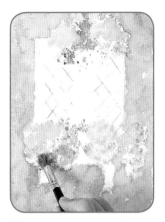

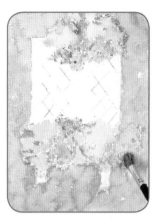

4 Still using the stippler, stipple touches of opera rose and cadmium yellow over areas of the windowbox and hanging basket.

5 Varying the colour with touches of bluebell and permanent rose, build up the remaining flower area.

6 Paint the remaining white areas of the windowbox and hanging basket with lightly stippled sunlit green.

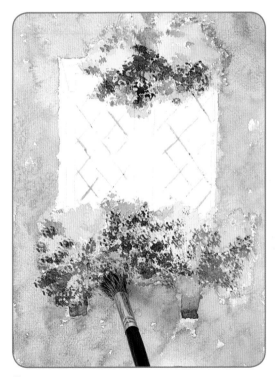

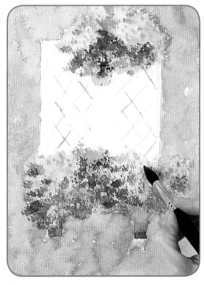

7 Paint the brackets of the windowbox with a dark mix of raw sienna, bluebell and a hint of opera rose. Once dry, lightly stipple country olive to establish the darker and shaded areas of foliage. Add a touch of bluebell to vary the hue. The paint should be fairly dry so that it does not diffuse. Build up the paint gradually.

8 Use the tip of the round brush to dab spots of opera rose and cadmium yellow over the pink and yellow flowers respectively.

9 Make a dark mix of bluebell, country olive and raw sienna, and paint in the windows. Aim for a hard edge on the sides, and use small dabs to give a broken effect to the areas next to the flowers.

10 Use the same mix with the stippler brush to add a few touches here and there across the foliage and allow to dry completely.

11 Gently remove the masking fluid, then use the round brush to touch in a few opera rose spots on the revealed white flowers. Use the same colour and technique to add more interest to the existing pink flowers.

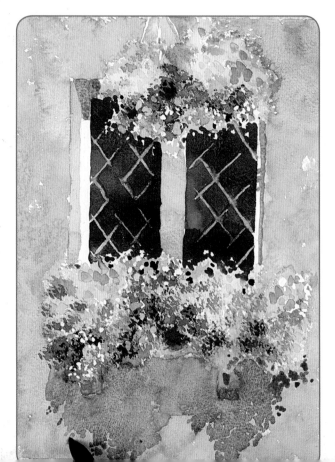

12 Apply a glaze of bluebell across the window frame and under the window box to represent shadows. Add some dots at the edges for the shadows of the flowers.

Opposite
Window Flowers
Allow the painting to dry to finish, then remove the masking tape.

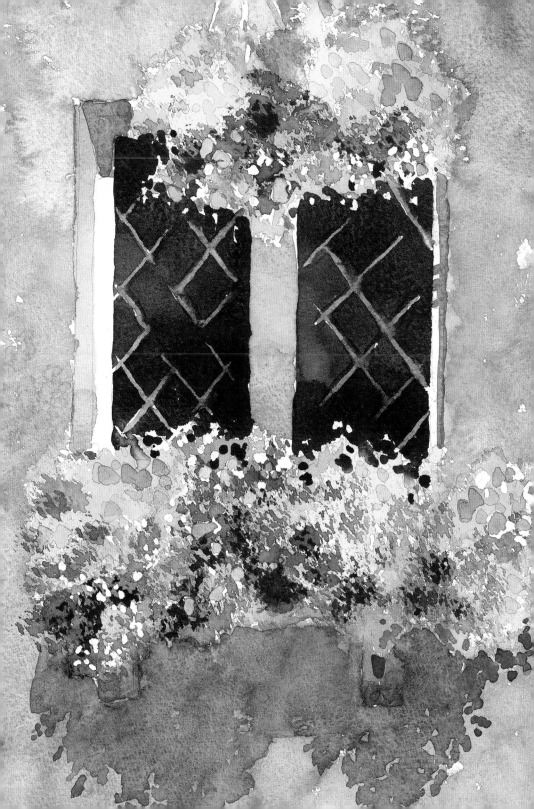

Spring Violas

Spring violas have so many different little 'face' combinations. Some are tiny, while others are bold and colourful; all are exciting to paint. Pick them from the garden in summer or use seed packets or pictures to inspire you to create your own compositions in the future.

Try combining gentle pinks and deep purples with bright yellows. Use any colour you have that seems similar to the flowers and you are sure to achieve success.

You will need
Saunders Waterford HP paper
Brushes: golden leaf, classic round, pointer
Paints: cadmium yellow, bluebell, permanent magenta, country olive, shadow
2B propelling pencil
Embossing tool

1 Use a 2B propelling pencil to sketch your initial lines on the paper, then border the edges with masking tape. Wet the whole painting with clean water and the golden leaf brush, then drop in cadmium yellow to the violas and pansies as shown, using the classic round brush.

2 Rinse your brush thoroughly, then use a mix of bluebell with a little permanent magenta to touch in the blue background flowers. Add a little more permanent magenta and suggest the pinky-purple of the pansies.

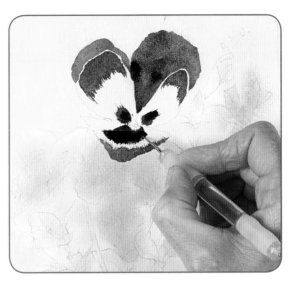

3 Add some cadmium yellow to country olive and use the mix to lay in a very delicate wash over the background.

4 Establish the dark areas on the top pansy using mixes of blubell and permanent magenta, applying the paint with the classic round brush. While it is still wet, use the embossing tool to tease out tiny lines into the lighter areas.

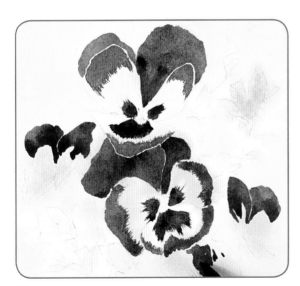

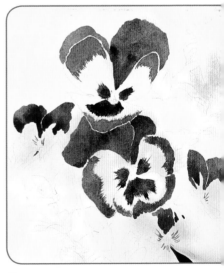

5 Paint the dark areas on the other large pansy and violas in the same way, adding more permanent magenta to the mix for the violas. Do not tease the dark areas on the violas.

6 Use the pointer to draw in the fine lines near the centre of the violas with the permanent magenta and bluebell mix.

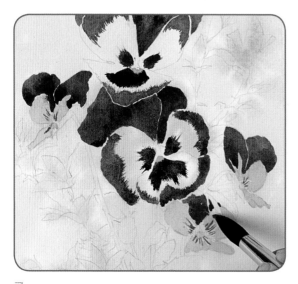

7 Add the pansy centres with cadmium yellow, applying the paint with the pointer. Still using cadmium yellow, change to the classic round and brighten the light parts of the violas.

8 Mix a touch of permanent magenta to bluebell and paint the small blue flowers with the classic round. As you paint each, use the pointer to attach the flower heads and buds to the stem with country olive.

9 Paint the pansy and viola leaves using the classic round brush to apply country olive. Vary the hue with the addition of touches of cadmium yellow.

10 Glaze the light areas of the top pansy using cadmium yellow.

Opposite
Spring Violas
Allow the painting to dry to finish, then remove the masking tape.

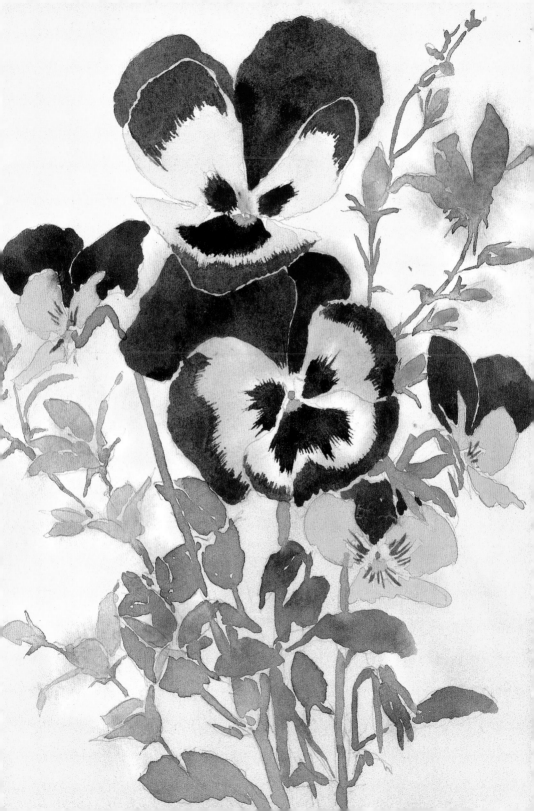

Index

achillea 26
allium(s) 8, 20
anemone(s) 18, 30, 37, 38

background(s) 7, 35, 39, 47, 48, 50, 51, 52, 53, 54, 57, 60, 61, 62, 69, 70, 72, 77, 82, 85, 88, 92, 93
blending 5, 8, 14, 20, 21, 34, 35, 40, 44, 50, 52, 54, 55, 56, 64, 77, 82
bluebell(s) 8, 11, 18, 25, 26, 38, 46, 56, 57, 58, 64, 73, 85, 86, 88, 92, 94
borage 43
bouquet 16, 17, 29, 76
Brompton stocks see stock(s)
bruising 5, 12, 30, 32, 64, 66
buddleia 47, 72, 73, 75
bud(s) 25, 41, 46, 61, 62, 65, 66, 72, 73, 94

camellia(s) 39
chive(s) 46
chrysanthemum(s) 51
classic round brush 7, 10, 16, 17, 22, 24, 36, 39, 40, 41, 44, 46, 54, 56, 60, 68, 69, 76, 77, 78, 80, 81, 84, 85, 88, 89, 90, 92, 93, 94
controlled strokes 5, 42
coreopsis(es) 48

daffodil(s) 56, 57, 58
daisy(ies) 36, 50, 76, 78
darning needle 12, 30
depth 23, 26, 27, 57
double loading 24, 25, 44, 56, 57, 64, 65, 70, 74, 80
 angled brush 44
 round brush 24
drawing 6, 13, 22, 32, 44, 64, 85
dropping in 9, 34, 53, 55, 57, 60, 68, 70, 76, 84, 85, 92

embossing tool 8, 12, 20, 30, 36, 38, 39, 44, 54, 64, 65, 66, 92, 93
erigeron(s) 26

flicking 14, 28, 29, 32, 38, 39, 48
foliage 8, 16, 21, 38, 39, 40, 42, 44, 51, 56, 57, 58, 60, 63, 89, 90
foreground 53, 54, 62, 65, 66
foxgloves 16, 34
freesia(s) 25, 76, 78

glazing 26, 27, 86
 golden leaf brush 10, 28, 39, 60, 62, 68, 69, 72, 73, 74, 76, 84, 85, 92
grass(es) 18, 32
gypsophila 76, 78

hair dryer 13
handkerchief 13, 50
heather 8
highlight(s) 36, 37, 57, 58
holly 42

iris(es) 44, 64, 66

kitchen paper 12, 36, 37, 39

lavender 26
leaf(ves) 8, 10, 18, 24, 28, 30, 33, 35, 38, 39, 40, 41, 42, 43, 47, 50, 53, 56, 57, 62, 70, 72, 73, 74, 76, 77, 78, 81, 82, 84, 85, 86, 94
 compound leaves 42
lifting and releasing 5, 22
lifting out 5, 36, 39, 77
lilac(s) 72
lily(ies) 22, 68, 69, 70
lupin(s) 20, 32

masking fluid 12, 13, 50, 51, 76, 77, 78, 84, 86, 88, 90
merging see blending
midground 53
mimosa(s) 46
morning glory(s) 35, 52
moving paint 12, 20, 32

nasturtium(s) 34
negative painting 16, 58, 85

orchid 18
overlaying 26, 27, 53

paints 11, 56, 60, 64, 68, 72, 76, 80, 84, 88, 92
palette knife 12, 28, 60, 64, 72, 80
pansy(ies) 52, 92, 93, 94
penstemon 42
petal(s) 16, 18, 22, 23, 24, 25, 26, 30, 33, 34, 36, 37, 38, 39, 44, 50, 53, 54, 56, 57, 58, 62, 63, 64, 65, 66, 68, 69, 72, 74, 80, 81
pink(s) 40

planning 6, 54
pointer brush 10
poppy(ies) 18, 23, 28, 30, 34
propelling pencil 13, 56, 60, 68, 72, 76, 84, 88, 92
putty eraser 13
pyramid brush 7, 10, 40, 41, 42, 43, 44, 47, 48, 60, 61, 62, 63, 64, 68, 70, 72, 73, 74, 76, 77, 78, 84, 86

rose(s) 11, 15, 22, 24, 25, 26, 28, 29, 38, 39, 40, 42, 44, 46, 54, 60, 61, 62, 63, 68, 69, 72, 73, 74, 75, 76, 77, 78, 84, 87, 88, 89, 90
round brush see classic round brush
ruling pen 12, 20, 88

salt 12, 48, 68, 70, 76, 77
salvia 16
scraping out 5, 32, 62, 64, 66, 73, 74, 80, 81
scribbling 14, 30, 38, 40, 47, 48, 70, 78, 86, 87
snowdrop(s) 50
soap 13, 50
spathe 64, 66
spattering 5, 28, 29, 78, 82, 84, 85
stalk 8, 18, 24
stamens 22, 30, 65, 66, 69
stem(s) 8, 16, 18, 20, 22, 24, 25, 30, 32, 37, 42, 46, 50, 53, 65, 66, 70, 78, 81, 85, 86, 94
stippling 10, 28, 46, 47, 54, 55, 57, 58, 62, 63, 73, 74, 75, 88, 89
stippling brush 46, 47, 60, 63, 72, 73, 74, 88, 89, 90
stock(s) 41, 84, 86, 87
sunflower(s) 33, 80, 82
sword brush 10, 40

teasing 5, 12, 20, 30, 4, 93
texture 12, 21
thistle(s) 27, 46
tulip(s) 8, 20, 21

vignette 5, 52, 64, 66
viola(s) 92, 93, 94

watercolour paper 12, 72
watercolour pencil(s) 13, 64, 80
wet into wet 7, 9, 54, 60
wet on dry 18, 54